Wedgwood

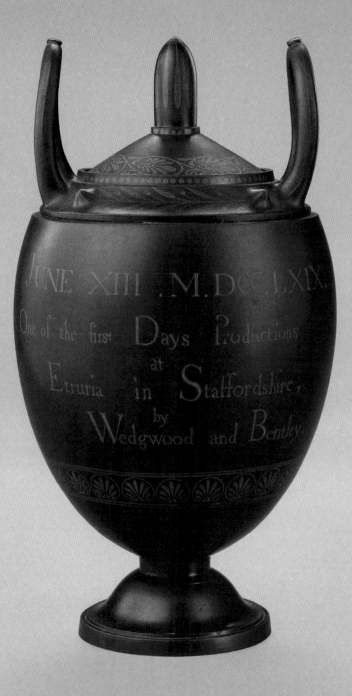

JUNE XIII .M.DCC.LXIX.
One of the first Days Productions
at
Etruria in Staffordshire,
by
Wedgwood and Bentley.

Wedgwood

CRAFT & DESIGN

Catrin Jones
Foreword by Tristram Hunt

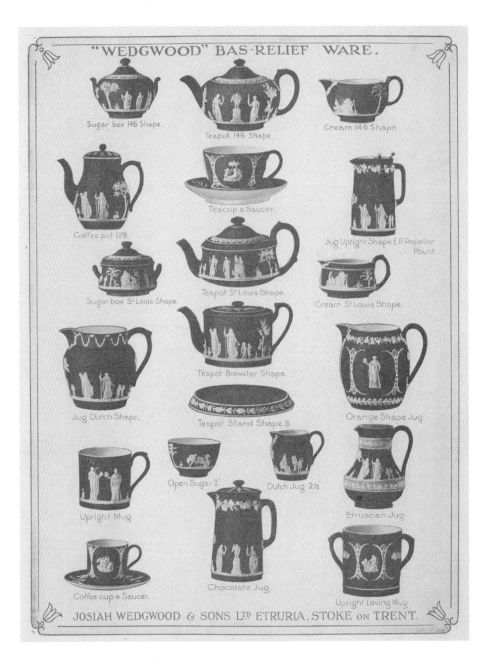

"WEDGWOOD" BAS-RELIEF WARE.

Sugar box 146 Shape.

Teapot 146 Shape.

Cream 146 Shape.

Coffee pot 129.

Teacup & Saucer.

Jug Upright Shape. E.P. Propellor Mount

Sugar box St Louis Shape

Teapot St Louis Shape.

Cream St Louis Shape.

Jug Dutch Shape.

Teapot Brewster Shape.

Orange Shape Jug.

Teapot Stand Shape. B.

Upright Mug

Open Sugar 3"

Dutch Jug 2½

Etruscan Jug.

Coffee cup & Saucer.

Chocolate Jug.

Upright Loving Mug

JOSIAH WEDGWOOD & SONS LTD ETRURIA, STOKE ON TRENT.

Contents

Foreword by Tristram Hunt

The founding of the South Kensington Museum (as the Victoria and Albert Museum was then known) took place a good half-century after the death of Josiah Wedgwood (1730–1795), at his home Etruria Hall, Stoke-on-Trent. Yet given the museum's unique combination of art and design, aesthetics and practicality, support for technical education and championing of creativity, I am certain that the 'Father of English Pottery' would have been a natural V&A supporter.

In 2014 the Wedgwood Collection was saved for the nation and placed in the trust of the V&A. Rightly it remains on display, for free, next to the Wedgwood factory in Barlaston, Staffordshire. This wonderful guide, by Chief Curator Catrin Jones, to our world-class holdings is one part of the V&A's mission to share the collection more widely, engage students and communities in Stoke-on-Trent with the museum and build a research and curatorial ceramics hub serving the Midlands.

This history begins with the work of the truly remarkable Josiah Wedgwood who, in the words of his epitaph at Stoke Minster, converted 'a rude and inconsiderable manufacture into an elegant art, and an important branch of national commerce'. The great Liberal Prime Minister W.E. Gladstone put it this way: 'Wedgwood was the greatest man who ever, in any age, or in any country … applied himself to the important work of uniting art with industry.' Wedgwood's marriage of technology and design, retail precision and manufacturing efficiency transformed forever the production of pottery, and helped to usher in the Industrial Revolution.

Looking through this expertly edited range of vases, medallions, dinner services and tureens, that is surely the lesson of Wedgwood: design and creativity are at the heart of a successful global brand. As his 1787 catalogue so presciently put it, 'The Desire of selling

Fig. 1 Illustrated admission ticket
to exhibition of Wedgwood's copy
of the Portland Vase, printed 1790;
bound in to his 1787 catalogue.
The National Art Library at the V&A:
38041800153355

much in a little Time, without respect to the Taste or Quality of the Goods, leads Manufacturers and Merchants to ruin the Reputation of the Articles which they manufacture and deal in'. When that culture of innovation and global awareness thrives – as it did again in the later nineteenth century as the company drew upon Japanese, French and Egyptian inspiration; and once more in that interwar design moment when Eric Ravilious and others updated and diversified the product line – then the company excels. Our role at the V&A is to ensure that future generations of ceramicists, designers, artists and entrepreneurs are able to study, enjoy and be inspired by this incredible collection born of the clays of Staffordshire.

Introduction

'Be it so, my dear friend, even so be it, let us begin, proceed & finish our future schemes, our days & years, in the pursuit of Fortune, Fame & the Public Good.'[1]

Josiah Wedgwood (1730–1795) declared in 1769 that his aim was to become 'Vase Maker General to the Universe'.[2] Wedgwood was a man of great determination, ability and energy, and the remarkable success of the ceramics company he founded is often attributed to these qualities. Any company in existence for more than 260 years is marked by periods of innovation and energy, and moments when it is more follower of fashion than tastemaker. That the Wedgwood company was able to continue to innovate after its early success is testament to its ability, at key periods in its history, to move with the times. The name 'Wedgwood' has come to stand for something far beyond its illustrious and energetic founder: uniting art and industry; pioneering artistic collaborations; the iconic blue and white of Wedgwood jasper. This book aims to tell that story through the lens of design, reflecting the continuing role that Wedgwood and its talented designers, artists and employees played in setting trends, responding to the market and producing high-quality, desirable ceramics for a broad range of consumers, always tied to the traditions established by Josiah Wedgwood in the eighteenth century. The examples showcased here represent just some of the achievements of Wedgwood and the many skilled people who have worked for the company from its foundation in 1759 to the present day, establishing Wedgwood as one of the most recognizable names in British ceramics.

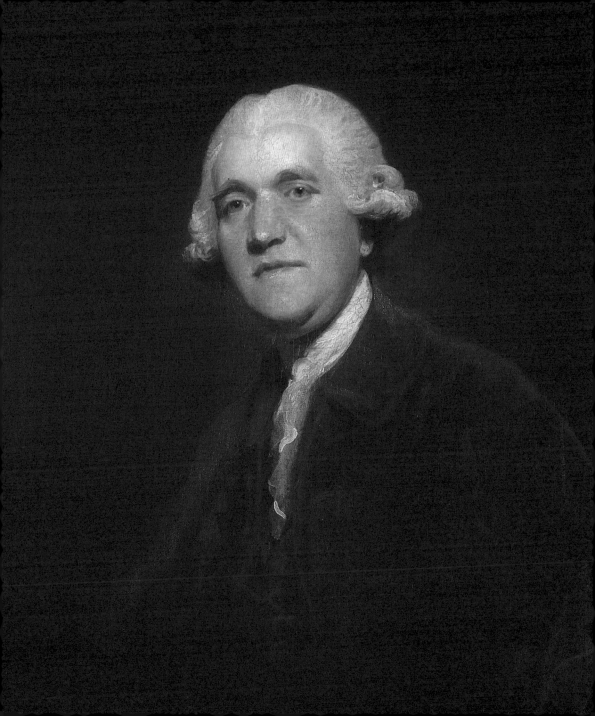

A product of its region

Wedgwood was by no means the only pioneering ceramics manufacturer in North Staffordshire (the area colloquially known as the Potteries for its signature industry), either in the eighteenth century or since. The six towns that now make up the city of Stoke-on-Trent (Burslem, Fenton, Hanley, Longton, Stoke and Tunstall) were perfectly located to become a ceramics production hub, rich in several different clays and the coal needed in great quantities to fire the kilns. The clays dug locally were used for a variety of red, yellow and grey ceramics. A growing community of potters manufactured a range of red and black earthenware, pots decorated with slipware glazes, and white salt-glazed ceramics in large quantities. The late seventeenth to mid-eighteenth century brought various innovations led by trailblazing potters in the region, including the Elers brothers, Enoch Booth and Wedgwood's one-time business partner, Thomas Whieldon. This period saw the widespread introduction of a number of new techniques and technical innovations, including a liquid lead glaze and the slip-casting technique (which enabled detailed designs to be replicated using plaster of Paris moulds), lathe turning, sprigging and stamping, all meaning that a great variety of new decoration could be produced in the latest styles.

The statesman and collector of Wedgwood's pieces William Gladstone (1809–1898) described Josiah Wedgwood as 'the greatest man who ever, in any age or country, applied himself to the important work of uniting art with industry'.[3] The narrative of the self-made man achieving global success began in Wedgwood's time and was later reinforced by Victorian literature, from Eliza Meteyard's two-volume biography (1865–6) to works by Samuel Smiles (1894).[4] Josiah Wedgwood's contemporaries William Adams, Humphrey Palmer, James Neale and John Turner all built successful businesses, appealing to many of the same consumers. In the nineteenth century other ceramic companies achieved enormous success: Spode with its blue-and-white earthenware; Minton with its colourful majolica and Victorian tiles; and Royal

10 INTRODUCTION

Doulton, which, keen to develop into new business areas, opened a factory in Burslem in addition to its operation in Lambeth, south London. In the twentieth century Midwinter led the way in modern design, and greater mechanization enabled Dudson and Steelite to cater to a global market in both the hospitality and the consumer sectors for high-quality British-made ceramics. Today Emma Bridgewater, 1882, Reiko Kaneko and smaller outfits in Stoke-on-Trent create modern bone china and creamware for discerning consumers, alongside thriving hospitality-ware companies. Wedgwood has continued in production as the industry has evolved around it, and the company's origins and heritage remain an important part of its story.

Britain in the eighteenth century was undergoing enormous change. Innovations at home, with the beginnings of the Industrial Revolution originating in the heart of the Midlands, were coupled with ruthless and strategic expansion abroad as this island nation continued to increase its wealth, prosperity and power throughout the world. A young Josiah Wedgwood watched Staffordshire become a major centre of ceramic production. By the 1750s a substantial workforce in the Potteries and a national network of suppliers enabled the potters of Stoke-on-Trent to cater to the latest fashions for luxury goods. Between the 1720s and 1760s the ceramics industry in Staffordshire grew exponentially, from small-scale pot-works producing coarse wares for local and country markets to large factories producing finely made teapots, coffee pots and plates for a new influx of customers as the country's prosperity increased and a consumer revolution began. Wedgwood came from a family of potters, and their business was one of many family-run potteries in the area: by 1750 there were already about 130 pot-works in Burslem. Josiah was apprenticed at the age of 14 to his brother Thomas at the Churchyard Works, the pottery founded by his great-grandfather, and he trained for five years to learn the 'Art of Throwing and Handleing', the skills essential for the master potter he became.[5]

Influences and commissions

During Wedgwood's training and early years as a potter he encountered a number of other innovators in the industry who influenced his approach. First, he entered into a business partnership with John Harrison and Thomas Alders of Stoke, and in 1754 he joined with the respected potter Thomas Whieldon (1719–1795) of Fenton. Whieldon's works attracted major figures in the Potteries, including William Greatbatch (1735–1813), a highly inventive potter and block-maker; the block-cutter and modeller Aaron Wood (1717–1785); and Josiah Spode (1733–1797), who went on to find huge success with his blue-and-white transfer-printed patterns. By the time Wedgwood had finished his training and established his own business in 1759, the region's potteries had shifted focus to a new product: cream-coloured earthenware. Wedgwood was to distinguish himself by carrying out hundreds of experiments to create a refined version of this widely used material and produce creamware that could rival porcelain in its design and decoration, yet cost far less to make. Wedgwood embarked with scientific rigour on the 'improvement of our manufacture of earthenware, which at that time stood in great need of it'.[6] He carried out a series of almost 5,000 glaze and body trials to

Fig. 3 'A good white Glaze', Josiah Wedgwood's Experiment Book, c.1760s V&A Wedgwood Collection, Barlaston (V&A Wedgwood Collection Archive: E26-19115)

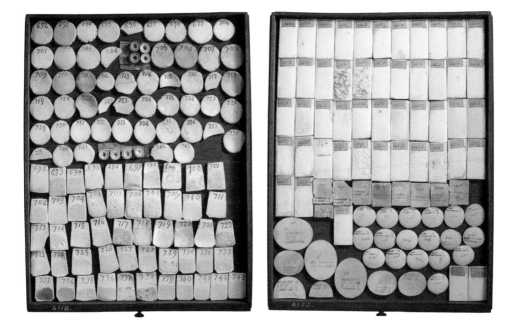

Fig. 4 Tray of Queen's Ware trials, 1765
Queen's ware
V&A Wedgwood Collection, Barlaston
(V&A: WE.7697-2014)

Fig. 5 Tray of Queen's Ware trials, 1765
Queen's ware
V&A Wedgwood Collection, Barlaston
(V&A: WE.4119-2014)

perfect the colour and finish of his creamware, diligently recording notes and ingredients lists in his Experiment Book. Owing to the very real threat of industrial espionage, the details of his recipes were written in code. After 411 trials, Wedgwood finally had a 'good white Glaze'[7] (fig. 3). Inspired by imported East Asian ceramics, European manufacturers had for centuries pursued the secrets of porcelain's unique qualities, from its translucency to its shell-like glassiness. By Wedgwood's day, princely porcelain makers from the Saxon manufactory of Augustus the Strong and Louis XV's Sèvres, to Nicholas Sprimont's Chelsea, and other manufactories at Bow, Plymouth and Bristol, had mastered the art of porcelain production, often at huge financial cost to themselves and their customers. The versatility and relative affordability of creamware were key to its commercial success, and for Wedgwood, it became a staple

Fig. 6 Bill for purchases made by the
Duke of Bedford from Josiah Wedgwood,
'Potter to Her Majesty', 1786
V&A Wedgwood Collection, Barlaston
(V&A Wedgwood Collection Archive:
L41-7309)

product with hundreds of styles in production, at just the moment
when new, increasingly aspirational customers of the middle classes
joined the aristocracy in seeking the latest fashionable wares.

Wedgwood was already on his way to commercial success when
a major opportunity presented itself. In 1765 an order came from
St James's Palace, London, for a creamware tea set 'with a gold
ground & raised flowers upon it in green' for Queen Charlotte.[8]
While Queen Charlotte's tea set sadly no longer exists, it rep-
resented a commission that would prove pivotal for Wedgwood.
It is a mark of the increased prestige of English pottery that a royal
order of this nature came to Staffordshire. Along with his tea set,
Wedgwood sent a crate of samples of his other wares, including
vases and improved cream-coloured earthenware. This bold tactic
resulted in further orders, but also, most importantly, in the fact
that in 1766, 'To this manufacturer the Queen was pleased to give
her name and patronage, commanding it to be called Queensware,
and honouring the inventor by appointing him Her Majesty's Potter.'
Creamware had become Queen's ware.

Wedgwood capitalized on his growing reputation. His new title, 'Potter to Her Majesty', was added to bill heads and orders (fig. 6). Staffordshire pots in this period were not typically marked by their maker, but Wedgwood began stamping the base of his wares as a mark of authenticity and quality. He adopted other marketing strategies to entice consumers, such as free delivery from his factory to London and free replacement of items broken in transit. He took out advertisements as a way to draw public attention to the company and celebrate its innovations; an example from 1769 published in the *St James's Chronicle* states, 'Queen's Ware and Ornamental Vases, manufactured by Josiah Wedgwood, Potter to her Majesty … he delivers the goods safe and Carriage free to London and without any danger of breaking … and is sold at no other Place in Town.' Recognizing the importance of a retail presence in fashionable hotspots, as well as showrooms at prominent addresses in the capital, Wedgwood opened shops in Bath and Dublin.

It was not only through the development and refinement of pottery types that Wedgwood sought improvement. Despite Staffordshire's geographical isolation, its ceramics were distributed not just locally but also internationally, via a growing network of turnpike roads and canals that offered key links from the Midlands to other trade routes. The cost of moving raw materials and the loss of fragile pots carried on poor-quality roads cut significantly into profits, so it is hard to understate the importance to the industry of improved transportation. Wedgwood played a critical role in the campaign to build the 'Grand Trunk' or Trent and Mersey Canal, completed in 1777, which would link Staffordshire directly to the major ports of Liverpool and Hull. Importantly, the newly built canal passed directly by his new purpose-built factory, which incorporated the latest working practices in the industry, from housing for his workers to a carefully designed factory layout with a logical and efficient sequence of production. Again, Wedgwood demonstrated his interest in improving every aspect of his operations.

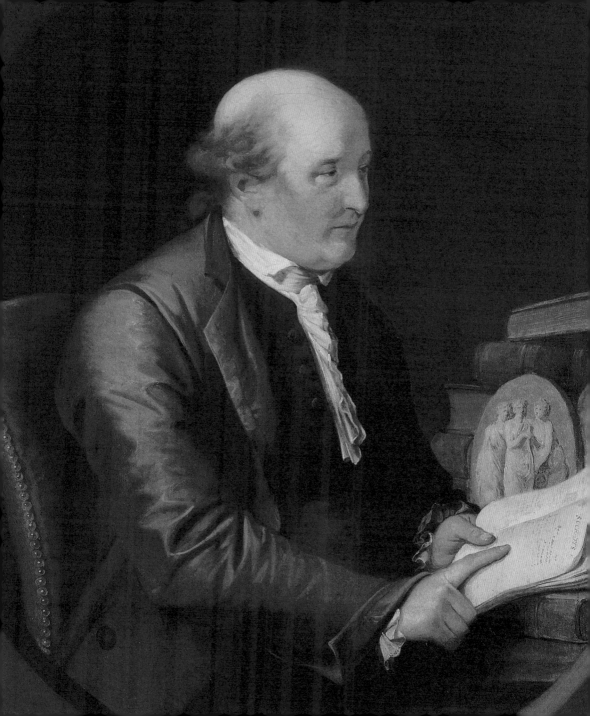

A crucial partnership

A chance encounter in 1762 with the Liverpool merchant Thomas Bentley (1731–1780; fig. 7), who became his mentor, friend and business partner, was a turning point in Wedgwood's life and career. The erudite, educated Bentley was soon Wedgwood's advisor on all things relating to taste, fashion and commercial advancement. For Wedgwood, their almost daily correspondence became 'my Magazines, Reviews, Chronicles, & I had almost said my Bible'.[9] Wedgwood wrote more than 1,200 letters to Bentley over the next 18 years, although, sadly, we have only half of the story, since few examples of Bentley's letters to Wedgwood survive (fig. 8). Wedgwood and Bentley's 'Ornamental' partnership, which continued until Bentley's death in 1780, focused on vases, more decorative ceramics and special commissions while Wedgwood's 'Useful' partnership, run with his cousin Thomas Wedgwood (1734–1788), produced the full range of Wedgwood's functional and dining wares.

Wedgwood relied on high-profile supporters – the influencers of the day – from fashionable architects, such as Robert Adam (1728–1792), James Wyatt (1746–1813) and William Chambers (1723–1796), to members of the nobility, such as Sir William Hamilton (1730–1803), Sir Watkin Williams-Wynn (1749–1789) and Georgiana Cavendish, Duchess of Devonshire (1757–1806). It was his partnership with the well-connected Bentley that enabled Wedgwood to build this network. Hamilton and Williams-Wynn owned impressive art collections that were shaped by a love of antiquity and a shared Enlightenment passion for discovery and the classification of knowledge, which would have a profound impact on Wedgwood's outlook and attitude to design. They provided examples of classical vases, cameos and works of art that became a sourcebook for Wedgwood and inspired his ceramic designs. Wedgwood was himself a voracious reader and, with Bentley, formed an important collection of reference books.[10] Such access and support gave his company a commercial advantage

Fig. 7 Portrait of Thomas Bentley, attributed to John Francis Rigaud, *c.*1780
Oil on canvas
V&A Wedgwood Collection, Barlaston
(V&A: WE.7524-2014)

Fig. 8 Letter from Josiah Wedgwood to Thomas Bentley, 23 January 1764
V&A Wedgwood Collection, Barlaston
(V&A Wedgwood Collection Archive: E25-18056)

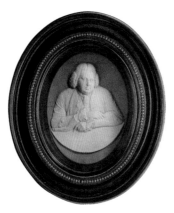

and resulted in an entirely new approach to the production of ornamental ceramics. Wedgwood's wide social circle established through Bentley and locally was important to his business success, and no doubt encouraged his scientific interests. He was part of a group of forward-looking industrialists, scientists and thinkers in the West Midlands, including the theologian and natural philosopher Joseph Priestley (1733–1804), the manufacturer and metal-working entrepreneur Matthew Boulton (1728–1809), the engineer James Watt (1736–1819) and Wedgwood's close friend the physician and poet Erasmus Darwin (1731–1802; fig. 9), who met to discuss the scientific and political issues of the day. This fascinating group of men travelled to their monthly meetings by the light of the moon, which allowed safer travel – and earned them their name, the Lunar Society.

Striving to innovate

Throughout his career Wedgwood pursued discoveries and technical improvements, working with a dedicated team of skilled artists, modellers and chemists from William Hackwood (1753–1836) to Alexander Chisholm (1723–1805). Wedgwood's Experiment Books are a unique survival, revealing the rigorous and methodical approach Josiah took during much of his adult life to refining and improving the materials used in his pottery manufacture (fig. 3). Each ceramic glaze and body trial is numbered and can be matched to the relevant entry in the Experiment Books. Having achieved major commercial success, Wedgwood continued to experiment, resulting in his most important contribution to ceramic history: the invention of jasperware. As he had done with his 'Queensware', Wedgwood carried out thousands of experiments to perfect his recipes and techniques for this revolutionary type of stoneware (fig. 10). Jasper could be produced in a wide range of fashionable colours and would become a visual marker for his company. Acutely aware

Fig. 9 Portrait Medallion
of Erasmus Darwin, 1773
Jasperware
V&A Wedgwood Collection, Barlaston
(V&A: WE.7570-2014)

Fig. 10 Tray of jasper trials, 1773
Jasperware
V&A Wedgwood Collection, Barlaston
(V&A: WE.7599-2014)

INTRODUCTION

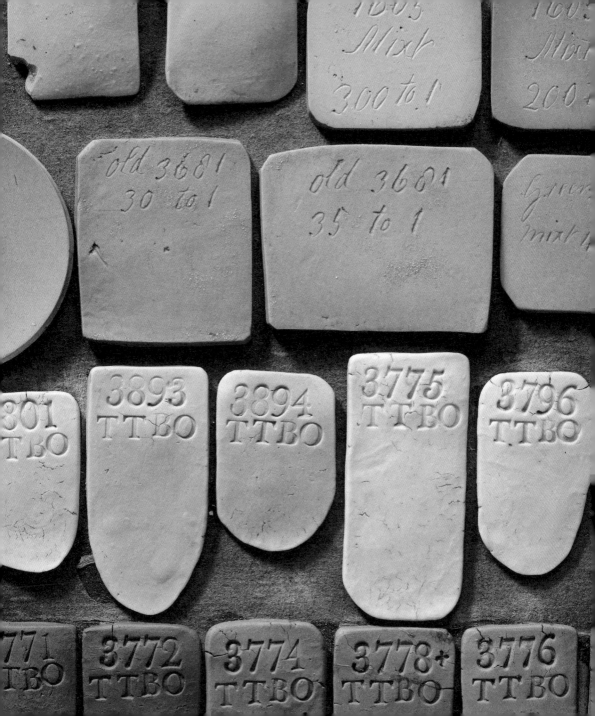

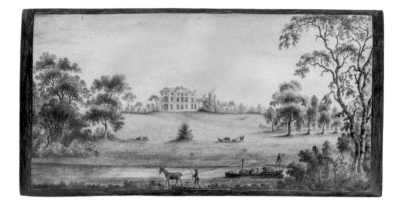

Fig. 11 Plaque depicting
Etruria Hall, 1773
Enamels on biscuitware
V&A Wedgwood Collection, Barlaston
(V&A: WE.7572-2014)

of the difficulty of measuring temperature accurately in the kiln, Wedgwood invented an apparatus called the pyrometer – calibrated, of course, in degrees Wedgwood – for which he was elected to the Royal Society in January 1783. These contributions to the technical development of ceramics proved as important to Wedgwood's interest and reputation as his designs.

While Wedgwood focused much of his attention on the learning that gave his enterprise an edge, either in being ahead of trends or in improving the efficiency of his manufacture, particular projects revealed his Nonconformist leanings and marked him out from both his peers and his aristocratic clientele. His interest in contemporary matters meant that he engaged with issues from the French and American revolutions to the improvement of working practice and factory arrangement. In 1787 Wedgwood became involved with the Society for the Purpose of Effecting the Abolition of the Slave Trade, which led to him producing a series of medallions for its members (41–2). Given his commercial focus, it is revealing that these medallions were not for sale, but were made for handing out at the Society's meetings in support of the cause. The abolition of the slave trade would not happen in Wedgwood's lifetime, although members of his family would continue the fight and were prominent Anti-Saccharites – boycotting sugar produced using

the labour of enslaved people – reflecting the interconnectedness of Empire and global consumption.

In 1766 Wedgwood purchased a grand 142-hectare estate and renamed it Etruria. This was to be the site of his family home, his new, state-of-the-art factory, and a village for his factory workers (fig. 11). As it did many of his contemporaries in the Potteries, a growing concern for business efficiency led Wedgwood to make changes in the organization and systematization of the ceramics factory, increasing specialization. Etruria enabled him to create a model for the industry, with separate zones for different types of production and clay.[11] While he was interested in creating good conditions for his workers, the men, women and children employed in the industry at Wedgwood and other potteries were exposed to often appalling working conditions and their associated health problems – such as exposure to lead, silicosis from inhaling clay dust, and exposure to extreme heat while rapidly unloading kilns – until stronger employee protection was introduced in the twentieth century. As a marker of his enormous success and his enduring impact on the city of Stoke-on-Trent, Etruria, as the area is still known today, is not a local name but one given by Wedgwood, based on the widely held misconception that the classical Greek and Roman pottery that provided him with so much design inspiration was Etruscan. It was at 'Etruria' that Wedgwood's bold ambitions were realized, beginning with the 'First Day's Vases' (14).[12]

'I scarcely know without a good deal of recollection whether I am a Landed Gentleman, an Engineer or a Potter, for indeed I am all three & many other characters by turns.'[13]

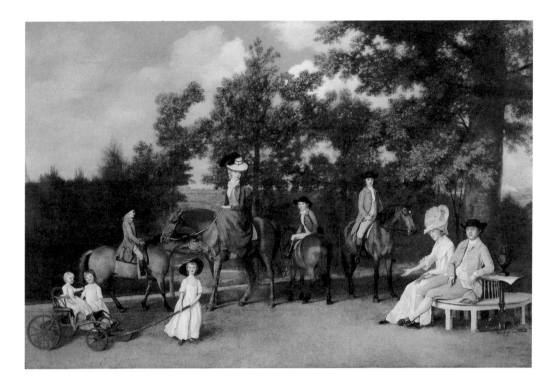

Fig. 12 George Stubbs
Wedgwood Family Portrait, 1780
Oil on wooden panels
V&A Wedgwood Collection, Barlaston
(V&A: WE.7853-2014)

INTRODUCTION

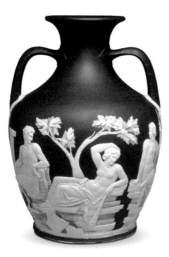

It was in the grounds of the family home at Etruria in the summer of 1780 that George Stubbs (1724–1806) painted a large conversation piece depicting the Wedgwood family: Josiah; his wife, Sarah; and seven of their eight children (fig. 12). Wedgwood felt there was 'much to praise and little to blame' in the picture, although he conceded that the likenesses were 'strong, but not very delicate'. Stubbs captures something of the character of Josiah Wedgwood as an individual, seated beside his wife, one leg (which had by this time been amputated as a result of lingering complications from a childhood illness, probably smallpox) appearing slightly stiff. He has a quill in hand, his papers and designs are laid out, a 'Shape No.1' vase in black basalt is beside him, and the smoke of his factory is visible in the background. Alongside the grand portraits of Josiah and Sarah by Sir Joshua Reynolds, these paintings reflect the success of the Wedgwood family.

A project that would dominate Wedgwood's final years was creating a perfect copy of the Portland Vase in his invented material, jasper (fig. 13). The cameo glass vessel, also known as the Barberini Vase, now in the British Museum, is thought to date from around AD 25. When the vase came to Britain in the hands of the ambassador at Naples, Sir William Hamilton, its reputation preceded it. Wedgwood and other connoisseurs would have been familiar with the object from prints, but it gained further prominence when Hamilton sold the vase to the Dowager Duchess of Portland (1715–1785), cuttingly described by Horace Walpole as 'a simple woman, and intoxicated only by empty vases'. The Portland Vase was among the most anticipated lots in the lavish thirty-eight-day sale of the Duchess's important collection after her death and it was bought by her son the Third Duke of Portland (1738–1809). Wedgwood's single-mindedness caused him to write to the Duke, days after the sale, requesting to borrow the vase so that he could copy it in jasper. After almost five years of trials and experimentation (43–5), he celebrated the creation of his perfect copy with a ticketed exhibition, concluding, 'My great work is

Fig. 13 First edition copy
of the Portland Vase, 1790
Jasperware
V&A Wedgwood Collection, Barlaston
(V&A: WE.8000-2014)

Fig. 14 Page from Josiah Wedgwood's
Commonplace Book, *c.*1770s–1795
V&A Wedgwood Collection, Barlaston
(V&A Wedgwood Collection Archive:
E39-28408)

the Portland Vase.' Today statues of Josiah Wedgwood show him holding this iconic object.

Wedgwood's story can be pieced together from the extensive archives held at the V&A Wedgwood Collection in Barlaston, Staffordshire, which includes much of Josiah Wedgwood's correspondence, business transactions and receipts, creating a picture of the relationships and clientele he built up as his business grew. Notes made throughout his life in his Commonplace Books capture many details of his ideas and interests, design process and approach (fig. 14). The Wedgwood factory's Oven Books, pattern books, factory models and ceramics, along with a wide range of correspondence, family history and material relating to the companies taken over by Wedgwood in more recent times, represent the company's history and that of the many designers, family members, artists and workers associated with it over more than two centuries.

After Josiah

Despite the potential for the loss of clear direction following the death of Josiah Wedgwood in 1795, the early nineteenth century remained a period of innovation for the Wedgwood company with the introduction of bone china, lustre decoration and the first underglaze-blue printed patterns. However, by the 1840s the firm's financial situation was increasingly precarious. Under the leadership of Josiah's grandson Francis Wedgwood (1800–1888) from 1842, the company formed partnerships with John Boyle and later Robert Brown, and disposed of assets including Etruria Hall and a large part of the estate, saving the company from financial ruin and raising capital to enable it to exhibit at the Great Exhibition in 1851. Under the management of Francis's sons Godfrey (1833–1905), Clement Francis (1840–1889) and Laurence (1844–1913), the company forged new links with art schools and embraced a burgeoning art pottery tradition that enhanced its output and reputation in the latter half of the nineteenth century.

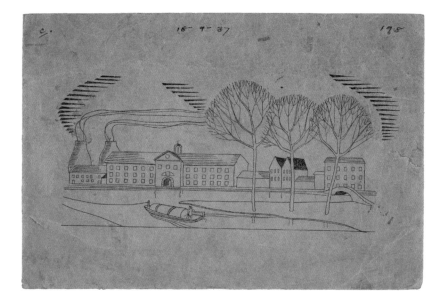

Fig. 15 Victor Skellern, sketch
of Wedgwood's Etruria factory, 1937
Pen and ink on paper
V&A Wedgwood Collection, Barlaston
(V&A Wedgwood Collection Archive: WoP 995)

Fig. 16 Designers and 'paintresses'
working in the museum at the
Etruria factory, c.1930s
Photograph
V&A Wedgwood Collection, Barlaston
(V&A Wedgwood Collection Archive)

During the twentieth century Wedgwood navigated further financial turbulence caused by tough competition, the impact of international instability and the outbreak of war. Key designers at the company during this period included the artists Alfred and Louise Powell, and the painter and designer Daisy Makeig-Jones. The takeover by a new generation of Wedgwoods in the 1930s, with Victor Skellern as art director and Norman Wilson as technical and production manager, resulted in a period of resurgence both financially and artistically, with the architect Keith Murray and the sculptor John Skeaping among those initiating new design approaches (figs 15, 16). Under the guidance of Josiah Wedgwood V (1899–1968), the company left the smoke-filled city of Stoke-on-Trent and the traditions of Etruria for a modern, purpose-built factory in rural Barlaston, a few miles south of the city, reaffirming Wedgwood's commitment to making high-quality and well-designed modern wares as well as honouring the company's history.

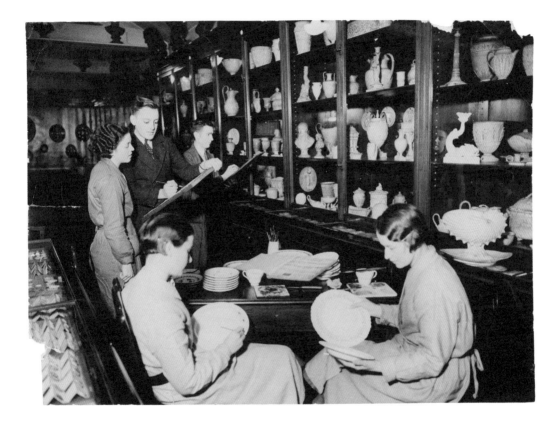

INTRODUCTION

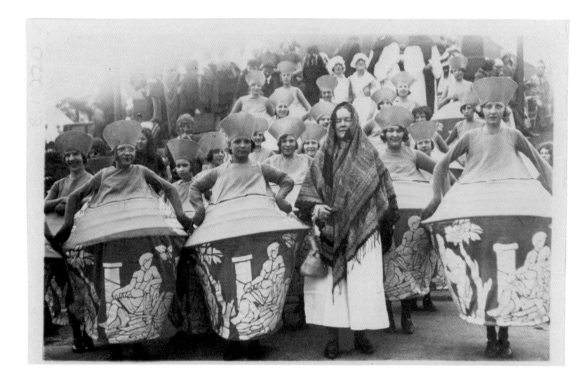

Fig. 17 Wedgwood employees dressed
up as Portland Vases at the Wedgwood
Bicentenary pageant, 1930
Photograph
V&A Wedgwood Collection, Barlaston
(V&A Wedgwood Collection Archive)

The Wedgwood dynasty produced many luminaries, and while some branches of the family remained involved with the business, others distinguished themselves in other areas. In the second generation, John Wedgwood (1766–1844) played a key role in the founding of the Royal Horticultural Society; Josiah Wedgwood II (1769–1843) remained a partner in the business and became the Member of Parliament for Stoke-on-Trent in 1832; Tom Wedgwood (1771–1805) carried out early experiments in photography; and Sarah Wedgwood (1776–1856) campaigned for the abolitionist and suffrage causes. In the third generation, the famed naturalist and author of *On the Origin of Species* (1859), Charles Darwin (1809–1882), was the youngest son of Josiah Wedgwood's daughter Susannah (1765–1817). Later descendants of Josiah include the composer Ralph Vaughan Williams (1872–1958), the historian Cicely Veronica Wedgwood (1910–1997) and the anthropologist Camilla Wedgwood (1901–1955).

The Wedgwood story is a complex and varied one, and accordingly the V&A Wedgwood Collection is unusual in its scope. Alongside a superlative ceramics collection, there are the archives and designs of a functioning factory, which are recognized by UNESCO as being one of the 'most complete ceramic archives in existence'. The archives also contain the extraordinary social history of Wedgwood – not only of the family, but also of the entire company. Letters, records of the workforce and photographs of people and events, such as the pageant to commemorate the bicentenary in 1930 of Josiah Wedgwood's birth (fig. 17), reveal the detail of the business's operations and the skilled individuals – many local to Stoke-on-Trent but also those drawn from an international artistic community – who contributed to Wedgwood's commercial success. In 2009 the high-profile collapse of the Waterford Wedgwood Royal Doulton (WWRD) Group threatened the future of the Wedgwood story, and the collection risked being sold to fill the company's multimillion-pound pension deficit. Thanks to the support of Art Fund and the National Lottery

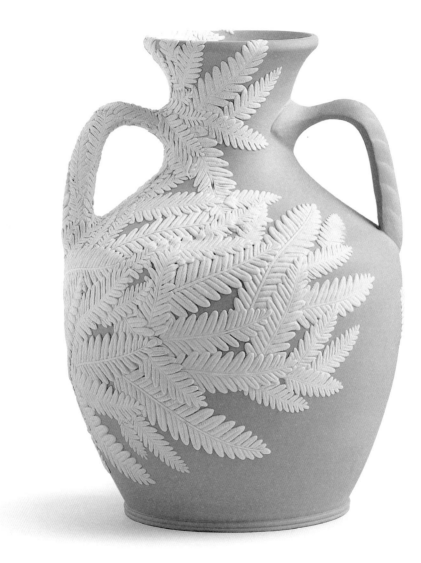

Heritage Fund, as well as the generous contributions of thousands of individuals and organizations, the collection and the archive were saved for the nation and gifted to the V&A in 2014. As the national collection of art, design and performance, the V&A is the natural home for one of the world's most important industrial collections.

In 2015 the Wedgwood company was purchased by the Finnish consumer goods company Fiskars (itself the custodian of the heritage family brand Fiskars, founded in 1649), which remains committed to the continuation of Wedgwood production at the Barlaston factory. Today this includes 'prestige' wares such as hand-painted objects and limited editions, and jasper, still made by a small team of skilled workers, while the rest of the company's output is produced in Indonesia. How to celebrate Stoke-on-Trent's important industrial past remains a key question as pressure on the industry continues. At the time of writing fewer than 20,000 people are employed in the ceramics industry, a figure that has shrunk from over 75,000 in the mid-twentieth century.

Looking back at key moments in the company's history, this book celebrates the visual power and great design encapsulated by Wedgwood from its founding in 1759 to the present day. It presents highlights from the V&A Wedgwood Collection, reflecting the unique proposition of Wedgwood's business: by operating in both the 'ornamental' and 'useful' markets, Wedgwood was able to bring innovative ceramic design to large areas of a captive market. These ceramics and their stories demonstrate the artistic heritage, craft and innovation that have become synonymous with the Wedgwood name.

Fig. 18 Hitomi Hosono, Shōka Vase, 2018
Jasperware

Plates

Wedgwood's pattern books played an important role in design, as an accurate reference record of each hand-painted motif for the factory painters. A fashionable customer could visit Wedgwood's showroom in London, Bath or Dublin and choose from the patterns and shapes to customize their Queen's ware dinner service. The eighteenth-century patterns were later assembled into bound volumes; a unique record of the extraordinary range of designs Wedgwood could offer to suit varying tastes and budgets. Each hand-painted pattern, from the plain to the elaborate, was cross-referenced with a short identifier and many Queen's ware designs remained in production into the twentieth century.

1. First Wedgwood Pattern Book, designs 1–20, c.1810
V&A Wedgwood Collection, Barlaston
(V&A Wedgwood Collection Archive: E62-33285)

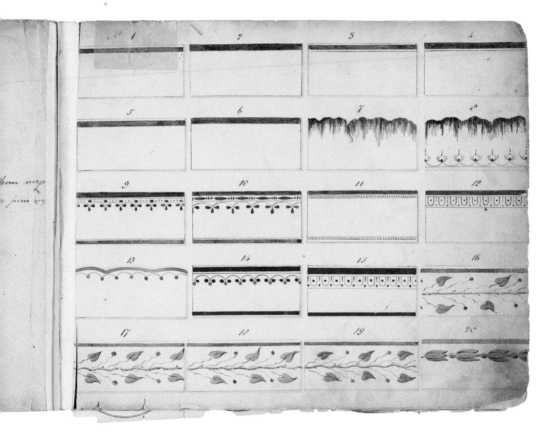

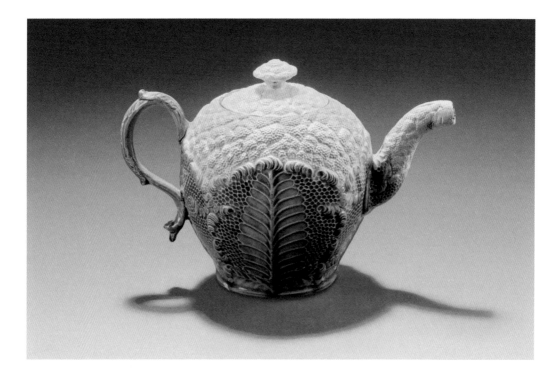

2. Cauliflower ware teapot, 1764
Earthenware with cream
and green glazes
V&A Wedgwood Collection, Barlaston
(V&A: WE.7479-2014)

Josiah Wedgwood's earliest innovation was a translucent bright-green glaze, perfectly suited to the rococo trend for playful *trompe l'œil* pots in the shape of fruit and vegetables. Using moulds and just two colours, Wedgwood made teapots, bowls and plates in the guise of cauliflowers, pineapples and melons, which could be produced cheaply and quickly. Other Staffordshire potters made similar wares, often sourced from the same mould-makers, making it difficult to attribute unmarked wares to a specific manufacturer. Even in the early years Wedgwood's commercial reach went beyond the Midlands, and he exported large quantities of 'colly flower' wares via European merchants.

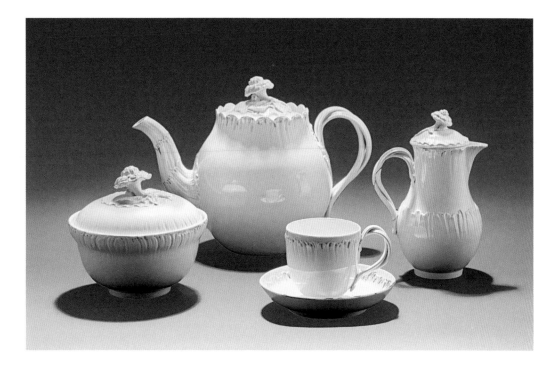

3. Early creamware tea set, c.1762–5
Moulded Queen's ware, glazed
and gilded
V&A Wedgwood Collection, Barlaston
(V&A: WE.7528-2014, WE.7600-2014,
WE.7602-2014 and WE.7601-2014)

Queen Charlotte's creamware tea set 'with a gold ground
& raised flowers upon it in green',[1] made by the future 'Potter
to Her Majesty', no longer survives, but this example shows
the 'Queen's ware' surface enhanced with gilding. When
Wedgwood produced his set, other Staffordshire potters had
already turned down this technically challenging commission.[2]
Wedgwood rose to the challenge with enthusiasm, quickly
ordering some gold powder and seeking advice on its
application.[3] The gold was painted over the glaze, so it is
often flaking off on early examples, but the detailed moulding
remains as clear as the day it emerged from the kiln.

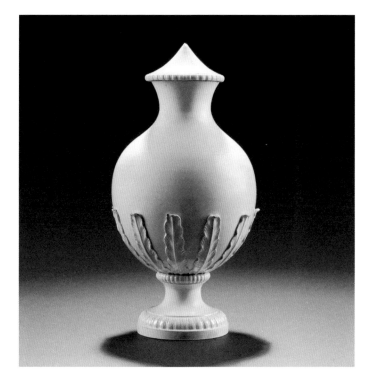

4. Vase with conical lid, *c.*1765–7
Queen's ware
V&A Wedgwood Collection, Barlaston
(V&A: WE.7494-2014)

5. Engine-turned vase and pedestal,
1765–8
Queen's ware
V&A Wedgwood Collection, Barlaston
(V&A: WE.7517-2014)

Wedgwood and Bentley seized on a market in the throes
of 'violent vase madness'. Wedgwood's early creamware
vases were experiments in new decorative techniques in the
neoclassical style, from acanthus leaves to patterns created
with the engine-turning lathe, introduced to the ceramics
industry by Wedgwood in 1763. Vases based on classical designs
were sold in garnitures or sets of three or five for the greatest
impact in fashionable interiors, and many originally had gilded
decoration, adding to their grandeur.[4] Only a small number
of these unusual vases survive, including those at Saltram
House, Devon, and the Potteries Museum & Art Gallery,
Stoke-on-Trent.

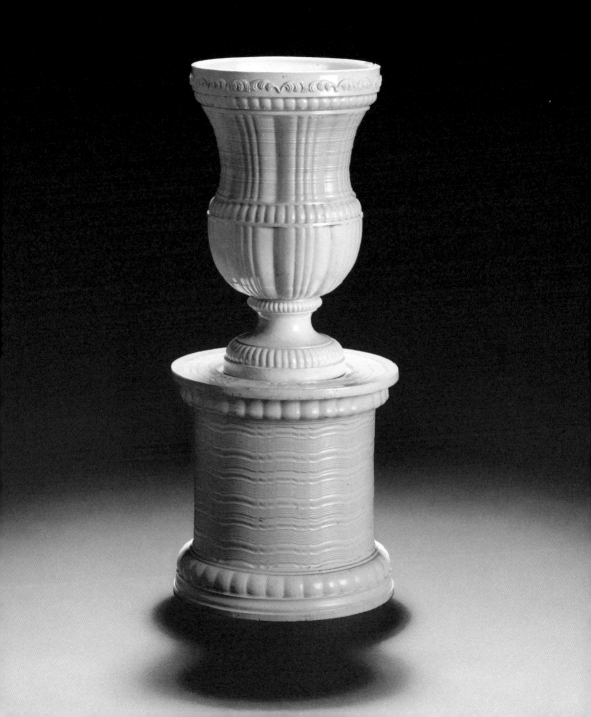

Wedgwood prided himself on offering many options to the discerning consumer, and choice was built into the buying process. Customers could visit the showroom, select their vase from a wide range, and specify their preferred finish from Wedgwood's ceramic bodies or surface decorations to suit their interior. The cost varied according to the size, decoration and materials used. Whether through black basalt or creamware with surface decoration resembling marble and semi-precious stones such as porphyry and agate, with or without gilding, the customer was able to demonstrate his or her good taste and knowledge of classical motifs as the design was transformed into a three-dimensional object.

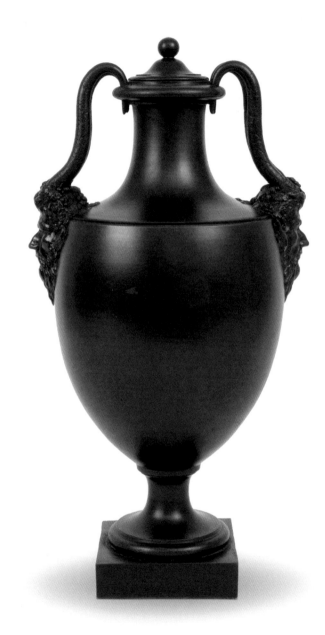

6. 'Shape No.1' vase, 1770
Black basalt
V&A Wedgwood Collection, Barlaston
(V&A: WE.7854-2014)

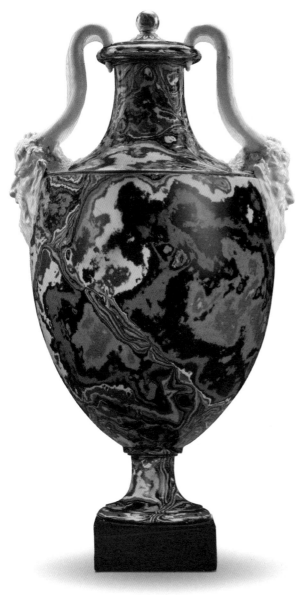

7. 'Shape No.1' vase, *c.*1770s
Agateware
V&A Wedgwood Collection, Barlaston
(V&A: WE.7931-2014)

8. 'Shape No.1' from Wedgwood
Shape Book, *c.*1780–90
V&A Wedgwood Collection, Barlaston
(V&A Wedgwood Collection Archive:
E54-30019c)

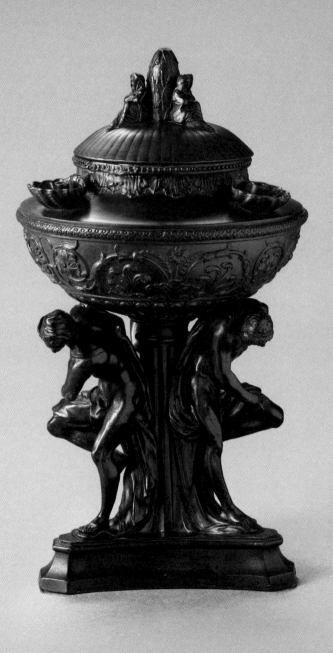

Made using the local clay
known as 'Carr', black-
firing clays were produced
by Wedgwood and his
competitors in the Potteries.
Wedgwood named his 'refined'
clay bodies such as black basalt
and jasper in reference to the
hard stones or marbles they
imitated. Like these luxurious
materials, Wedgwood's clays
could be cut or polished to
a high shine. Turning to
both classical sources and
contemporary designers,
Wedgwood created an
enormous range of inventive
and fashionable neoclassical
designs, which were translated
into clay by his company's
skilled modellers.

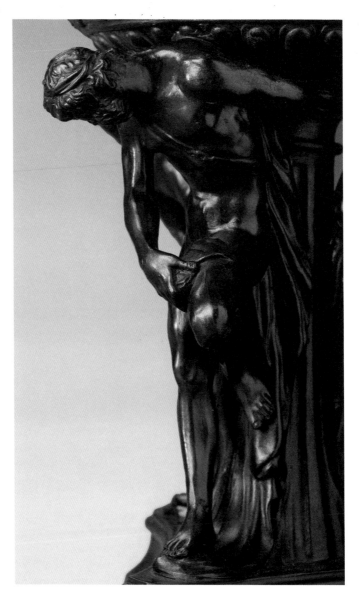

9. Michelangelo lamp, *c.*1785
Black basalt
V&A Wedgwood Collection, Barlaston
(V&A: WE.7974-2014)

10. Vase and cover with porphyry
glaze and gilding, and terracotta base,
*c.*1769–80
Earthenware with black basalt plinth
Victoria and Albert Museum, London
(V&A: 1102-1855)

11. Snake-handled vase, 1775–8
Agateware
V&A Wedgwood Collection, Barlaston
(V&A: WE.7932-2014)

It was in decorative vases that the self-appointed 'Vase
Maker General to the Universe' would consolidate his success.[5]
In Europe, porcelain represented the ultimate in desirability for
the wealthy. Wedgwood's genius was in refining and improving
the wares of Staffordshire to make pottery as fashionable – and in
some cases as expensive – as porcelain. From 1773 he produced
catalogues showing an enormous range of ornamental shapes,
translated into French, German and Dutch for growing foreign
markets. In the catalogue from 1787, a single vase retailed from
7s 6d upwards, while a grand set could cost up to 6 guineas.[6]

The form and decoration of many of Wedgwood's grand vases took inspiration from illustrations in Hamilton's *Collection of Etruscan, Greek and Roman Antiquities* (13). In 1772 the British Museum had acquired Hamilton's collection, including the fourth-century Apulian vase on which this Wedgwood model is based.[7] Wedgwood suggested that his classical-style vases had in two years generated three times what Parliament had paid for Hamilton's important collection, and his commercial success was no doubt helped by access to that collection before the designs were published. In 1769 Wedgwood took out his first and only patent for encaustic decoration: 'Completely to imitate the painting upon Etruscan vases; but to do much more; to give Beauty of Design.'[8]

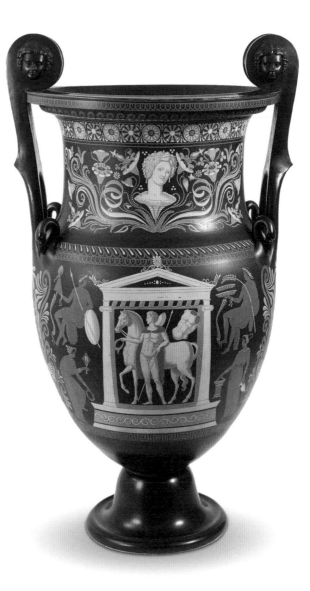

12. Krater vase with painted encaustic decoration, *c.*1785
Black basalt
Victoria and Albert Museum, London
(V&A: 2419-1901)

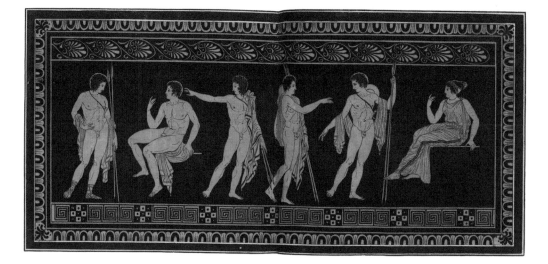

13. 'Hercules in the Garden of the
Hesperides', vol. 1, plate 129 of *Collection of
Etruscan, Greek and Roman Antiquities from
the Cabinet of the Hon. Wm Hamilton His
Britannick Majesty's Envoy Extraordinary at
the Court of Naples*, Pierre-François Hughes
D'Hancarville, 1766
V&A Wedgwood Collection, Barlaston
(V&A Wedgwood Collection Archive)

14. 'First Day's Vases', 1769
Black basalt with encaustic decoration
V&A Wedgwood Collection, Barlaston
(V&A: WE.7568-2014 and WE.7569-2014)

In 1769 the new ornamental works at Etruria were opened,
an event that was celebrated by Wedgwood personally
throwing six 'First Day's Vases', with Thomas Bentley
turning the handle of the potter's wheel. Four emerged from
the kiln; three are still in North Staffordshire today.[9] Their
form and decoration were borrowed straight from antiquity:
Wedgwood's supporter Sir William Hamilton had a renowned
collection of works of art from antiquity, designs from which
were published in 1766–7. The date in Roman numerals and
the inscription 'Artes Etruriae Renascuntur' – the Arts
of Etruria are Reborn – stated Wedgwood's ambitions
for his new venture.

15. Factory model for Wedgwood's
'Bat Vase', c.1785
Biscuitware
V&A Wedgwood Collection, Barlaston
(V&A: WE.2494-2014)

Wedgwood's factory models reveal the extraordinary complexity of making and reproducing an object in clay. The model-maker skilfully adapted the design on paper to create a master model in unglazed stoneware, slightly larger than full size to allow for the shrinkage of the clay. This model was used to create plaster moulds for use in the manufacturing process, and was kept as a record. Working moulds were used up to 12 times before they began to lose their definition and a new set was made. This original design, based on an illustration after Johann Bernhard Fischer von Erlach, was adapted by the Wedgwood modellers through the addition of fashionable Egyptian-style motifs.

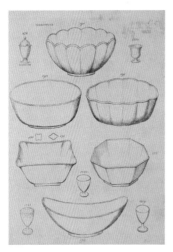

In 1767 Wedgwood wrote to Bentley, 'the demand for this said Creamcolour, Alias Queen's Ware ... still increases. It is really amazing ... how universally it is liked.'[10] Part of the appeal was Wedgwood's continual updating of the range. A proliferation of shapes and patterns according to the latest fashions – from grand dinner services to unusual products such as asparagus holders – were designed and vigorously marketed, making the most of the factory's skilled modellers and often borrowing from the design lexicon of contemporary silver. Wedgwood's Queen's ware catalogues (introduced in 1774) were available in English and French, and offered hundreds of fashionable and decorative shapes.

16. Plate 8 from the Wedgwood Catalogue of 1815, engraved by William Blake, c.1815
V&A Wedgwood Collection, Barlaston
(V&A Wedgwood Collection Archive: E47-29319)

17. Supper set, c.1790–1810
Queen's ware
Victoria and Albert Museum, London
(V&A: CIRC.279-1910)

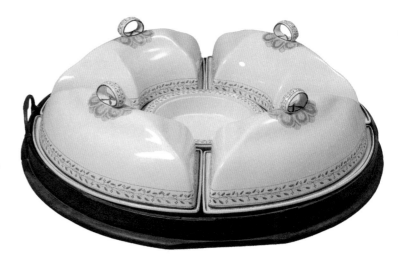

Wedgwood ran two separate strands of business: the 'Ornamental' partnership, with Bentley, and the 'Useful' partnership, with his cousin Thomas. That is not to say that Wedgwood's functional wares were not ornamented nor his decorative pieces functional, but this separation allowed the two areas to develop into different ranges with differing markets. The success of creamware, both for Wedgwood and for his competitors including the Leeds Pottery, was such that in 1774 Wedgwood wrote to Bentley: 'I apprehend our customers will not much longer be content with Queens Ware, it being now render'd vulgar, & common every where.'[11] Wedgwood's solution was to introduce new products, including 'pearlware', a whiter earthenware body with a blue-toned glaze, closer in colour to porcelain.[12]

18. Epergne in the Queen's
ware catalogue, 1790s
V&A Wedgwood Collection, Barlaston
(V&A Wedgwood Collection Archive:
E47-29312)

19. Tureen, cover and stand,
c.1770–1
Moulded Queen's ware
Victoria and Albert Museum, London
(V&A: 2335 to B-1901)

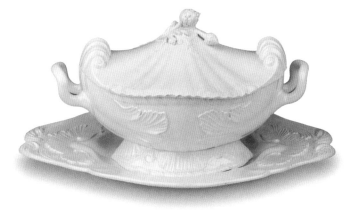

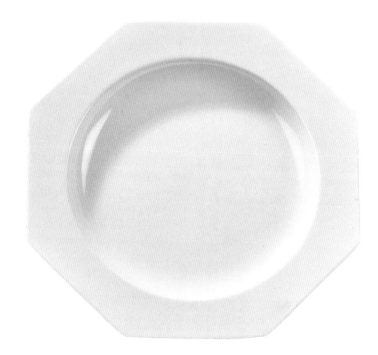

20. Octagonal dinner plate, 1765
Queen's ware
V&A Wedgwood Collection, Barlaston
(V&A: WE.7529-2014)

21. Engine-turned honey pot, 1770–5
Queen's ware
V&A Wedgwood Collection, Barlaston
(V&A: WE.8274-2014)

While elaborate decoration was a Wedgwood speciality, employing some of the most talented artists in the Potteries and in Wedgwood's Chelsea Decorating Studio (which operated from 1769 to 1784), by no means was all the firm's Queen's ware highly decorated. Plainer surface decoration allowed the moulded forms and refined cream-coloured body and glaze to sing, but it also meant that consumers could combine or match it with their other ceramics. Wedgwood continued to produce Queen's ware catalogues until the 1920s. Many of the eighteenth-century designs have a striking simplicity that would be echoed in the company's twentieth-century shapes and styles.

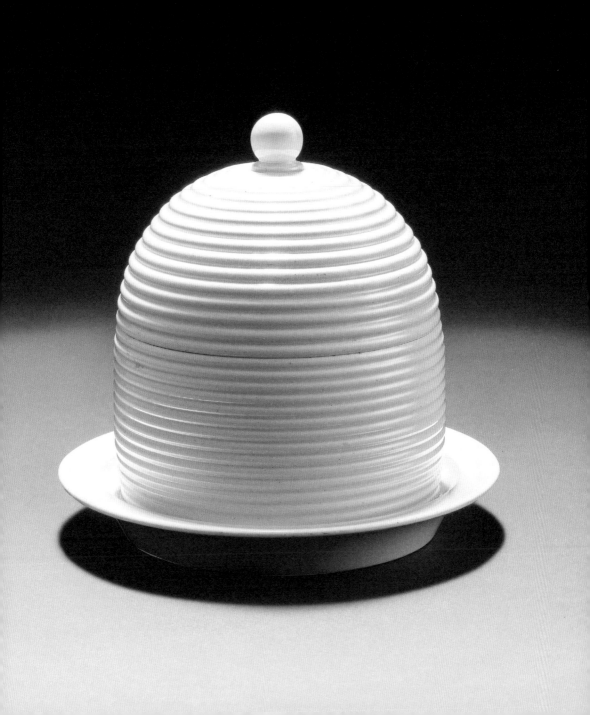

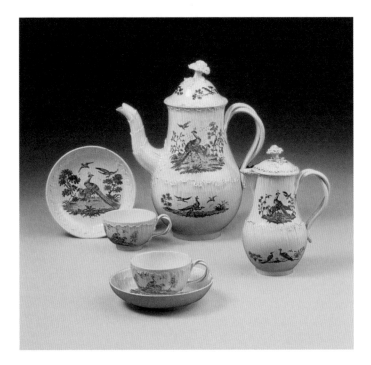

22. Part of a coffee service, *c.*1775
Queen's ware with transfer-printed
decoration in enamel
Victoria and Albert Museum, London
(V&A: 414:1155-1885, 414:1155-1885, 414:1156-
1885 and 414:1157-1885)

As well as hand-painting, Wedgwood recognized the
potential of transfer-printing from popular engravings to
create up-to-the-minute designs cheaply. For this, the firm
partnered with the Liverpool-based merchants John Sadler
and Guy Green, who had perfected the transfer technique.
While underglaze transfer-printing would later dominate
the ceramics world with Spode's much-reproduced Willow
Pattern, in the eighteenth century printing was carried out
over the glaze and drew on a rich repertoire of prints that
were in circulation, such as the popular design book *The
Ladies Amusement, Or, The Whole Art of Japanning Made
Easy* (1762).

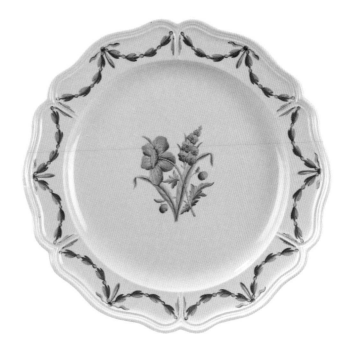

23. Husk Service dinner plate, 1770
Queen's ware
V&A Wedgwood Collection, Barlaston
(V&A: WE.8152-2014)

The success of Wedgwood's Queen's ware dinner ranges relied on the company's skilled painters at Etruria accurately copying each of the repeating designs captured in the Wedgwood pattern books (1). In 1770 the noted Anglophile Empress Catherine the Great of Russia ordered a lavish dinner service with a botanical 'husk' pattern in pink, which was painted at Wedgwood's studio in Chelsea. Wedgwood wrote to Bentley that he 'trembled as well as you for the Russian service', aware of the importance of this prestigious commission for future dinnerware sales.[13] It was very unusual for Wedgwood and Bentley – the 'Ornamental' partnership – to oversee the decoration of a dinner service rather than the 'Useful' partnership run by Wedgwood's cousin Thomas.

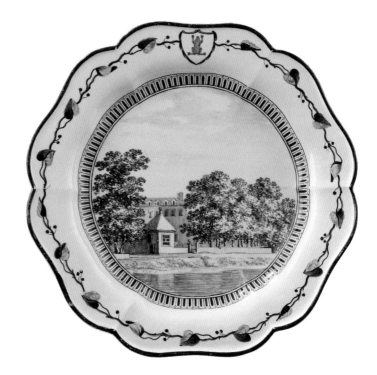

24. Dinner plate for the Frog Service, depicting 'A view up the Thames between Richmond and Isleworth', 1773
Queen's ware
V&A Wedgwood Collection, Barlaston
(V&A: WE.8159-2014)

In 1773 Wedgwood secured a second major commission from Catherine the Great: the Frog Service, a 952-piece dinner and dessert service for 50 people for her summer palace, built in a frog marsh outside St Petersburg. Undoubtedly Wedgwood's most ambitious creamware project, the service was hand-painted with 1,222 different views of British landscapes, gardens and antiquities, with Bentley advising on which should be included. The scenes were taken from engravings and drawn from life, making the service a unique record of eighteenth-century England.

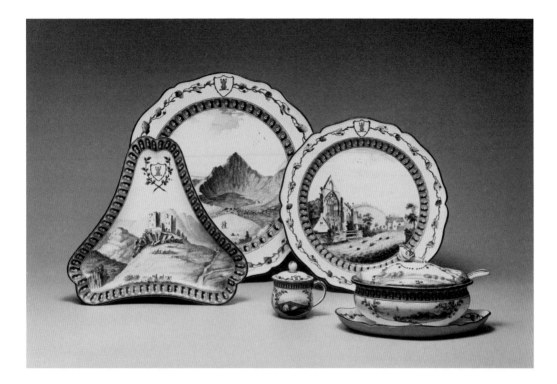

25. Comport, plates, custard cup and
tureen for the Frog Service depicting
'Wales Views', 1773
Queen's ware
Hermitage Museum, St Petersburg

Manufacturing the Frog Service pushed Wedgwood to his
limits, and he was required to take on more painters and artists
at Etruria and his London studio to finish the project. This
vast commission for 'my Great Patroness in the North'[14] was
produced at the extraordinary cost of £2,290.[15] Wedgwood
was always alert to marketing opportunities, and before it was
shipped to Russia, the service was displayed in his London
showroom, with tickets supplied, on application, to the nobility
and gentry.[16] A few test plates remained at Etruria, including
dessert plates accidentally painted with the oak-leaf border
rather than an ivy pattern.

26. Tray of jasper trials, 1773
Jasperware
V&A Wedgwood Collection, Barlaston
(V&A: WE.7599-2014)

By the 1770s Josiah Wedgwood was a huge commercial success. Even as his factory produced an ever-growing range of desirable goods, he was working on a completely new invention: jasper. As with Queen's ware, he embarked on thousands of experiments over several years to perfect the material. Precision was key, and some trials were marked with instructions for the 'oven men' on kiln placement: 'TTBO' stands for 'tip top of the biscuit oven'. Jasper, a high-fired stoneware that could be translucent like porcelain, could also be coloured, cut and polished, making Wedgwood's versatile invention the perfect match for the taste for classical art.

27. Portrait medallion
of John Flaxman, 1787
Jasper in a later wood frame
V&A Wedgwood Collection, Barlaston
(V&A: WE.7921-2014)

John Flaxman Jr (1753–1836), son of a modeller and plaster-maker, was one of the first students at the Royal Academy Schools in London, and is regarded as the best British sculptor of his generation. He designed friezes, cameos and portrait medallions for Wedgwood, creating some of the company's most famous designs. The earliest reference to Flaxman Jr in the V&A Wedgwood Collection archives is a signed receipt from 1775 for work completed by Flaxman – but because at this date his father was also supplying Wedgwood with casts and moulds, it is difficult to be certain who modelled which piece.

Wedgwood's jasper was well suited to highly detailed designs, from miniature portraits to decorative vases and plaques in the fashionable neoclassical style. It could be coloured with a range of mineral-oxide stains to perfectly match the neoclassical interiors designed by Robert Adam and his contemporaries. As ever, Wedgwood engaged the top artists and designers of the day, from John Flaxman Jr to William Hackwood (Wedgwood's chief modeller) and the sculptor Henry Webber (1754–1826). These skilled artists were able to create extraordinary three-dimensionality, with undercut detailing that was technically challenging and difficult to fire, but visually striking.

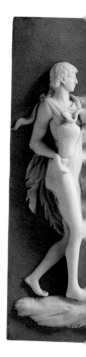

28. 'Birth of Bacchus' plaque, 1776
Jasperware
V&A Wedgwood Collection, Barlaston
(V&A: WE.7777-2014)

29. 'Dancing Hours' plaque, 1778–80
Jasperware
V&A Wedgwood Collection, Barlaston
(V&A: WE.7920-2014)

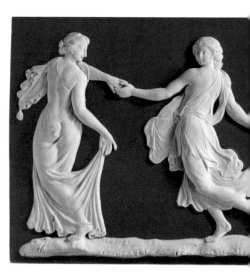

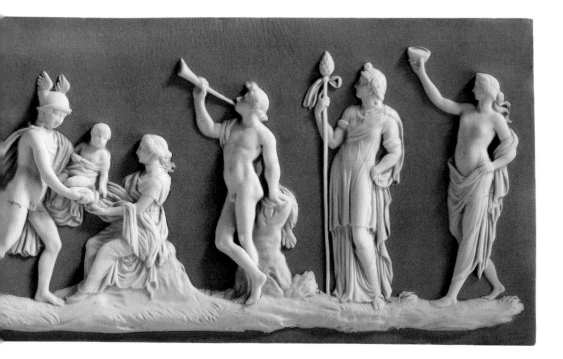

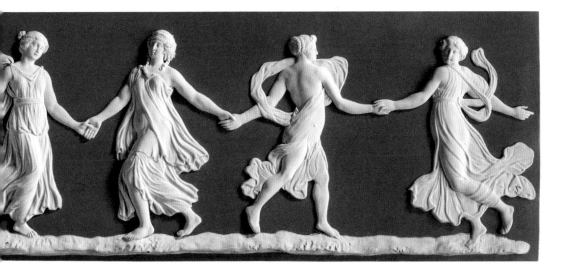

Wedgwood's extensive series of black basalt and jasper medallions of famous historic and contemporary figures reflected the eighteenth-century mania for portraiture. Josiah Wedgwood wrote to Thomas Bentley in 1776, 'People will give more for their own Heads, or Heads in fashion, than for any subjects, & buy abundantly more of them.'[17] His letters to Bentley on the subject of portraits of the victor of whichever battle reveal the pace of production: 'Oh Keppel Keppel – Why will you not send me a Keppel. I am perswaded if we had our wits about us as we ought to have had 2 or 3 months since we might have sold 1000 £ worth of this gentlemans heads in various ways.'[18] Borrowed from prints, ivories and waxes or produced on commission, likenesses were first sculpted in wax on slate, moulded in plaster, cast in clay and fired; working moulds were then taken from this clay 'standard'.

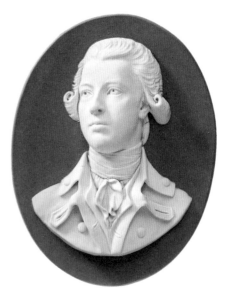

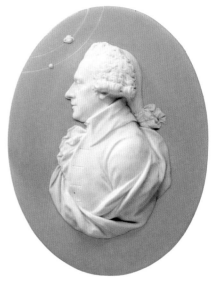

30. Selection of portrait
medallions, 18th century
Jasperware
V&A Wedgwood Collection, Barlaston
(V&A: WE.7977-2014 to WE.7983-2014)

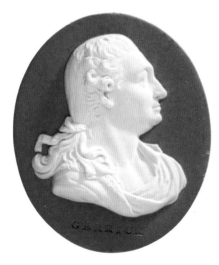

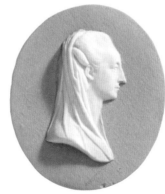

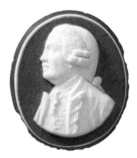

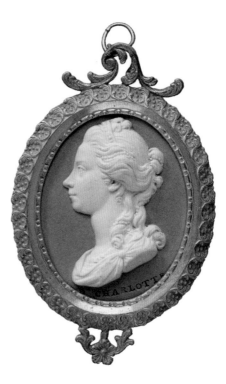

31. Queen Charlotte portrait
medallion, 1780
Jasperware in gilded metal frame
V&A Wedgwood Collection, Barlaston
(V&A: WE.7818-2014)

The heads of members of the British Royal Family were
particularly popular subjects for portrait medallions in the
eighteenth century. Wedgwood produced several versions of
medallions featuring King George III and Queen Charlotte, as
well as many of their children. He also responded to the demand
for portraiture of other European royals and made medallions
of the Holy Roman Emperor, Leopold II; King Louis XVI and
Queen Marie Antoinette of France; Queen Maria of Portugal;
Catherine the Great of Russia; and King Gustavus III of Sweden.
Wedgwood also made medallions of famous French statesmen
such as Lafayette and Jacques Necker, and Revolutionary
figures, in the 'Heads of Illustrious Moderns' series.

Wedgwood's distinctive combination of blue and white jasper is used to great effect on this vase, designed by John Flaxman (27) based on a classical example illustrated in Hamilton's *Antiquities*. The grand scale of this vase, at almost 50 cm high, was a major technical achievement. Wedgwood considered his 'Pegasus' vase to be 'the finest and most perfect I have made',[19] so much so that in 1786 he presented one to the British Museum – which accepted, despite its general policy of not acquiring works of contemporary manufacture.[20]

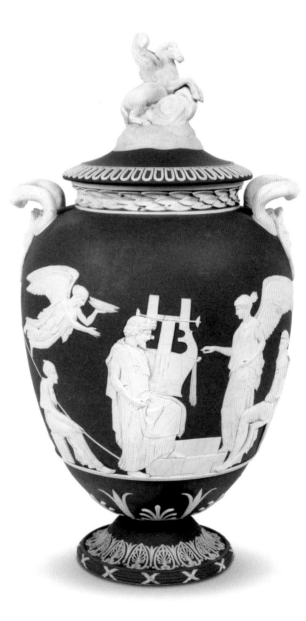

32. 'Apotheosis of Homer' vase, 1786
Jasperware, with later pedestal
V&A Wedgwood Collection, Barlaston
(V&A: WE.7446-2014)

In addition to jasper, Wedgwood's experiments in creating refined new clay bodies continued with 'Rosso Antico', a red terracotta introduced in the mid-1770s, and 'white terracotta' stoneware from 1779. Developed during the 1770s using mainly Staffordshire clays, caneware was particularly suited to fashionable bamboo designs. Wedgwood continued to adjust the colour, and caneware did not appear in the company's *Catalogue of Ornamental Wares* until 1787, when large quantities of caneware teapots and vases were produced, many with enamelled decoration.

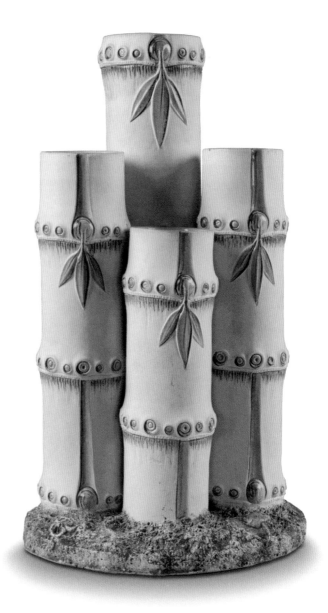

33. Bamboo ware bowl, *c.*1785–90
Caneware
Victoria and Albert Museum, London
(V&A: 2385-1901)

34. Game pie dish, 1843
Caneware
V&A Wedgwood Collection, Barlaston
(V&A: WE.8557-2014)

The design of this caneware game pie dish playfully unites ornament and function, as the ceramic stands in visually for the pastry of game pie on the table. Manufactured in five sizes, these 'raised pie' dishes (as they were described in factory records from 1795) became especially popular during a period of flour shortages brought about by the Napoleonic wars. Caneware designs were well suited to moulding and applied decoration, such as the detailed reliefs of grapes and game and a rabbit finial on this dish.

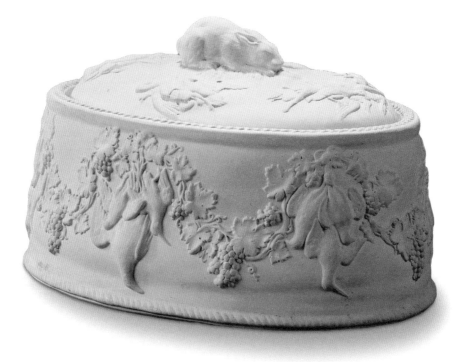

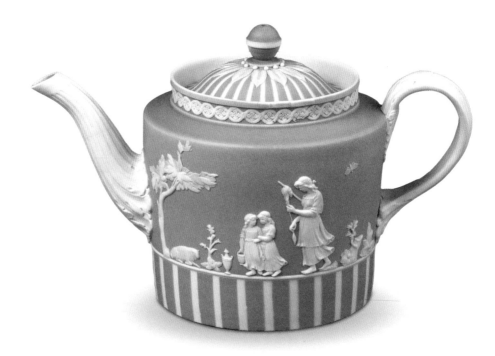

35. Teapot and cover, 1785–90
Jasperware
Victoria and Albert Museum, London
(V&A: 414:1152-1885)

Wedgwood recognized the commercial potential of women both as potential customers and as designers. Lady Diana Beauclerk (1734–1808), Elizabeth, Lady Templetown (c.1746–1823) and Emma Crewe (c.1768–1850) all produced designs for Wedgwood bas-reliefs in the eighteenth century. The 'exquisite taste' and 'charming groups' of these women were marketed as part of the product's appeal, with subjects including imagery of motherhood, 'Domestic Employment' and sentimental figures including 'Poor Maria'. Their drawings and 'cut Indian paper' designs were modelled by William Hackwood. It is thought that because the artists themselves were aristocratic women, they were not paid for their work.

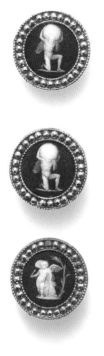

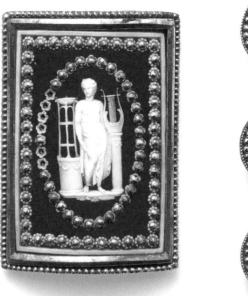

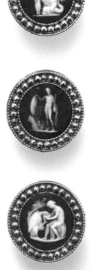

36. Selection of mounted
jewelry: a buckle and six
buttons, *c.*1785–95
Cut steel-mounted jasper
Victoria and Albert Museum, London
(V&A: 277/A-D-1866 and 5818-1853)

Jasper worked well on any scale, from large vases and plaques
to tiny reliefs, and the choice of subject indicated the taste and
knowledge of the piece's owner. Wedgwood's catalogue of 1779
explained, 'The Ladies may display their Taste in a thousand
Ways, in the Application of these Cameos; and thus lead Artists
to a better Stile in ornamenting their Works.'[21] The fashion-
conscious could choose from thousands of different subjects,
mounted as brooches, buttons, hairpins and buckles, and used
to adorn both men's and women's dress. The plaquettes were
sent to various Birmingham metalworkers, including fellow
Lunar Society member Matthew Boulton, for mounting in
gilt metal or cut steel.

Inspired by the late eighteenth-century fashion for Egyptian antiquities, the form of this black-basalt vase is based on canopic jars, used to hold viscera during the mummification process. Wedgwood's model, painted in encaustic enamels, was moulded in one piece and therefore could not be used as a container, becoming a purely decorative object. The vase belonged to Josiah Wedgwood's great friend the doctor and poet Erasmus Darwin, founder of the Lunar Society. There are a number of Wedgwood references in Darwin's epic poem *The Botanic Garden* (1789–91), including passages on Etruria, Wedgwood's anti-slavery medallion and the Portland Vase.

37. 'Canopic' vase, 1790
Black basalt
V&A Wedgwood Collection, Barlaston
(V&A: WE.7807-2014)

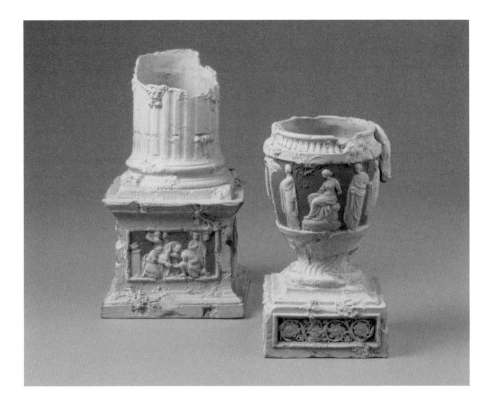

38. 'Ruined Column' vases, *c.*1786–95
Jasperware
Victoria and Albert Museum, London
(V&A: 1519-1855 and 131-1906)

The rediscovery of Europe's classical past fuelled a fashion for creating novelties from antiquities. British elites embraced the 'Grand Tour' of Europe's artistic heritage, from ancient ruins and sculptures to the excavations at Pompeii and Herculaneum, as an essential part of a 'classical' education. Wedgwood offered products that captured this romanticism, including 'ruin'd column' vessels, also described as 'flower pots' in Wedgwood's Oven Books, made in white and blue jasper.[22] They were manufactured between 1785 and 1795, and in 1786 a 'ruin'd vase' cost 15 shillings and a 'single column' 21 shillings.[23]

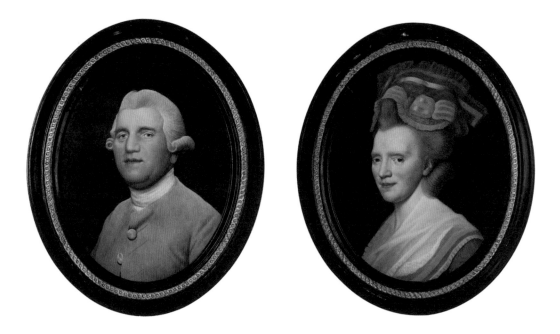

39. George Stubbs, portraits of
Josiah and Sarah Wedgwood, 1780
Enamel on Queen's ware plaques
V&A Wedgwood Collection, Barlaston
(V&A: WE.7522-2014 and WE.7523-2014)

Josiah Wedgwood's wife, Sarah (1734–1815), closely advised
him on personal and business matters. He wrote in 1768,
'I speak from experience in Female taste, without which
I should have made but a poor figure amongst my Potts,
not one of which, of any consequence, is finished without
the approbation of my Sally.'[24] This unusual pair of portraits
are painted in enamel on exceptionally large ceramic plaques
made by Wedgwood for George Stubbs, who was undertaking
his own experiments to improve enamel painting. Stubbs also
re-created two of his engravings of his more usual subject
matter, horses, as Wedgwood plaques.

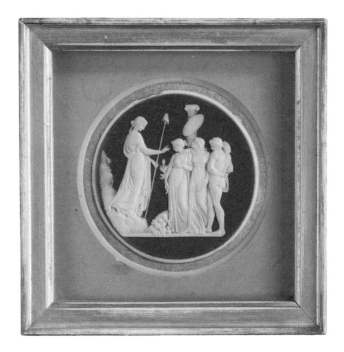

40. French Revolution medallion, *c.*1789
Jasper in a giltwood frame
V&A Wedgwood Collection, Barlaston
(V&A: WE.7841-2014)

As a man with Radical dissenting political views, and aware of the strong market for his ceramics in France, Josiah Wedgwood watched the French Revolution play out with interest. Initially supportive of the cause, he became disillusioned as the Revolution became ever more violent. The success of his commemorative wares relied on a swift response to capture the moment, and sometimes necessitated recycling and adapting motifs. Henry Webber's design for the Sydney Cove medallion, made to commemorate the first European settlement of Australia and depicting Hope attended by Peace, Art and Labour, was adapted so that Hope became Revolutionary France with the addition of a Phrygian cap and a shield with a fleur-de-lis.[25]

In 1787 Wedgwood produced a medallion in jasper to raise awareness of the inhumanity of the slave trade. A forerunner to the protest badge, the medallion was made to be worn and was distributed free of charge at abolitionist meetings. The shocking image of the kneeling enslaved man in chains, asking 'Am I Not a Man and a Brother?', was based on the seal of the Society for the Purpose of Effecting the Abolition of the Slave Trade.[26] Correspondence between Josiah Wedgwood and abolitionists including Olaudah Equiano (*c.*1745–1797),[27] Thomas Clarkson (1760–1846) and William Wilberforce (1759–1833) reveals Wedgwood's closeness to the campaign, a fight that was continued by his children.[28] His expanding business nonetheless relied on the global trade and the iniquity of sugar production and empire-building.

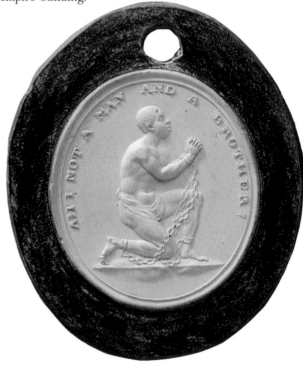

41. Anti-slavery medallion
block mould, *c.*1787
Biscuitware
V&A Wedgwood Collection, Barlaston
(V&A: WE.7842-2014)

42. Anti-slavery Wedgwood
medallion, *c.*1787
Jasperware with gilt-metal mount
Victoria and Albert Museum, London
(V&A: 414:1304-1885)

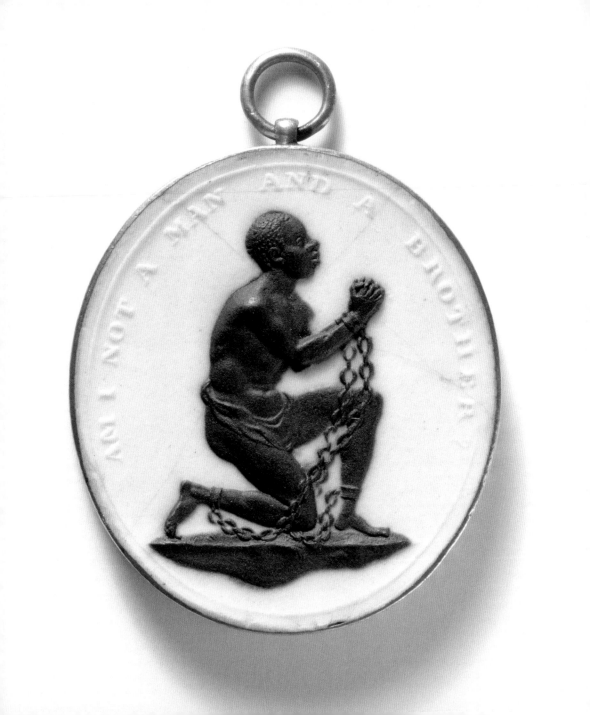

43. Trials for bas-reliefs for
the Portland Vase, *c.*1789
Jasperware
V&A Wedgwood Collection, Barlaston
(V&A: WE.8121-2014 and WE.8122-2014)

44. Full-size trial copy of the
Portland Vase, *c.*1789
Jasperware
V&A Wedgwood Collection, Barlaston
(V&A: WE.7999-2014)

45. Full-size trial copy of the
Portland Vase, *c.*1789
Jasperware
V&A Wedgwood Collection, Barlaston
(V&A: WE.7998-2014)

In 1786 Wedgwood embarked on a project to create from
jasper a perfect copy of the cameo glass vessel (AD 25,
today in the British Museum) known as the Portland Vase.
Wedgwood's top modellers and artists carried out hundreds
of trials to re-create accurately the form, colour, texture
and finish of the original, which he borrowed from the Duke
of Portland. Combining the finest applied decoration with
hand-painted slip, every detail (and imperfection) on the
original was re-created in clay. The trials, with their flaking
and bubbling surfaces, reveal the technical challenges of such
a complex project. Four years later Wedgwood had achieved
his goal of re-creating – if not surpassing – the art of antiquity
with his copy.

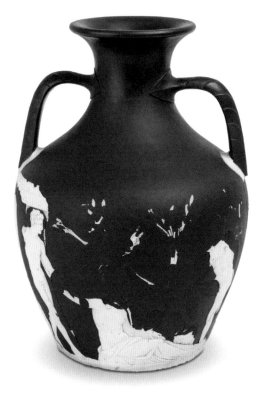
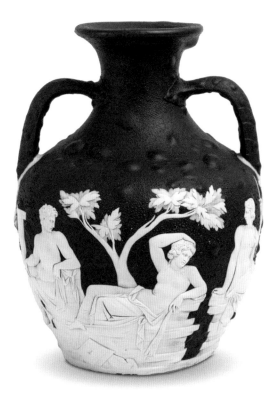

Ever on the lookout for novel forms, Wedgwood introduced paintboxes in the catalogue of 1779, described as 'a set of large and small vessels and neat palats for the use of those who paint in water colour'.[29] Available in jasper, black basalt and white terracotta with slip decoration, the design made the most of the smooth impermeability of Wedgwood's clay bodies. This example, with its lotus knop, dimpled background and bas-reliefs of 'Boys at Play', would have been both a useful and prestigious object for ladies of leisure, appealing to the fashion for amateur artists and painting outdoors.

46. Lotus knop paintbox set, with paint pots and palettes, 1785–90
Jasperware
V&A Wedgwood Collection, Barlaston
(V&A: WE.8303-2014)

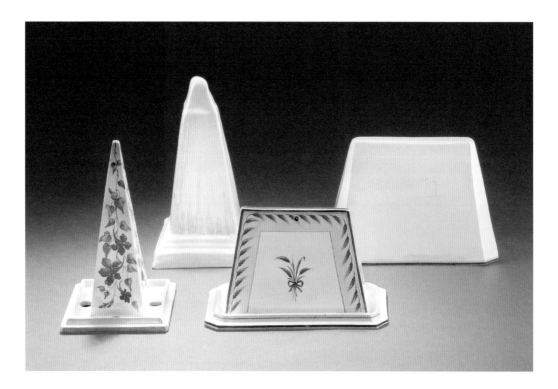

47. Jelly moulds, *c*.1785
Queen's ware
V&A Wedgwood Collection, Barlaston
(V&A: WE.8279-2014 and WE.8281-2014)

48. Page from Charles Gill's travelling
salesman notebook featuring designs
for jelly moulds, *c*.1815
V&A Wedgwood Collection, Barlaston
(V&A Wedgwood Collection Archive:
E54-30027)

Jelly moulds were made in two parts, of which the interior
was decorated with enamel designs and the outside left
undecorated. The hollow outer mould would be filled with
jelly or coloured gelatine, and the inner mould inserted until
the jelly was set. On careful removal of the outer mould, the
painted pattern was visible through the jelly, creating an
appealing table decoration. These designs featured in the
notebook of Charles Gill (fl.1805–1826), one of Wedgwood's
first travelling salesmen. It offers an insight into the
Wedgwood shapes and patterns available to his customers,
as well as their cost.

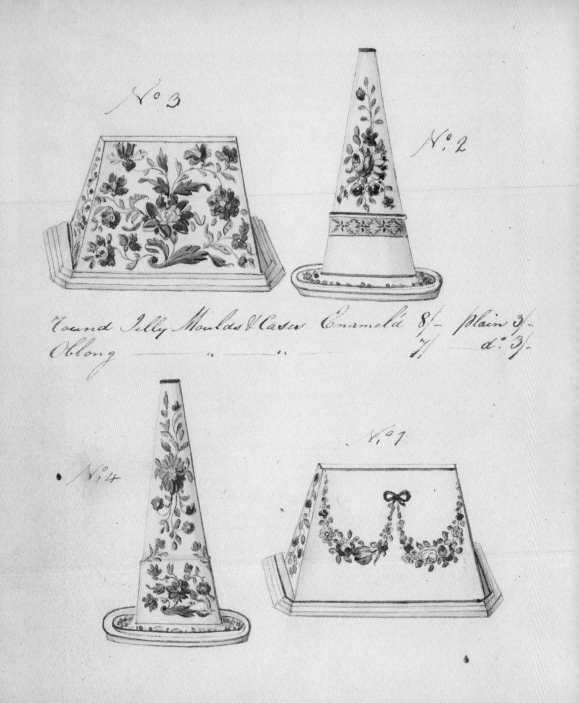

No 3

N.º 2

Round Jelly Moulds & Cases Enamel'd 8/ — plain 3/
Oblong ———— " ———— " 7/ ———— d.º 3/

N.º 4

N.º 1

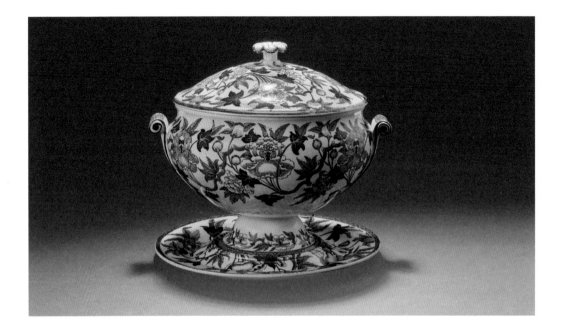

49. Tureen decorated in 'Peony' pattern,
*c.*1820
Queen's ware
V&A Wedgwood Collection, Barlaston
(V&A: WE.8492-2014)

John Wedgwood, Josiah I's eldest son, was a founding member of the Royal Horticultural Society in 1804. His interest and a general fashion for the study of plants resulted in Wedgwood introducing a number of transfer-printed blue-and-white botanical patterns, including 'Peony', 'Hibiscus', 'Waterlily', 'Chrysanthemum' and 'Botanical Flowers', many of which continued in production into the twentieth century. The 'Peony' pattern, based on engravings by William Hales, is first recorded in the archives in 1806. In September 1807 the Prince of Wales ordered a dinner service for 12 people with additional gilded decoration.[30]

Bone china was introduced at Wedgwood for a short period
from 1812 before being discontinued in 1822, although
replacements for broken china were available until 1831. It was
not until 1878 that bone china production began in earnest at
the Etruria factory and a full range of teaware and dinnerware
was available. Historic Wedgwood designs such as this Imari-
type pattern were also reintroduced, often transfer-printed
and embellished with additional hand-painted decoration or
gilding. Here, the 'Old Japan' pattern is used on a form called
'Silver Shape', reflecting Wedgwood's continued combination
of influences to create new products. Quality was always
important: the company aimed to produce 'articles of the
highest quality for the requirements of the best markets,
our chief object being to secure excellence'.[31]

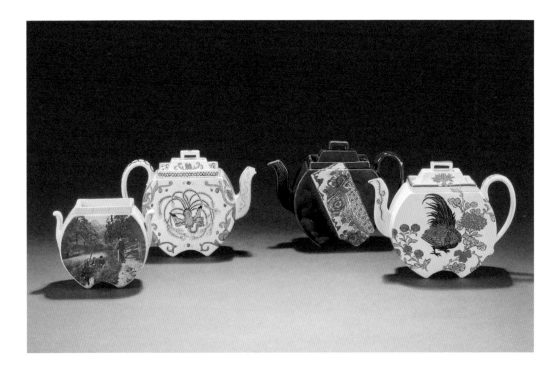

51. 'Satsuma' teawares, 1873–8
Queen's ware
V&A Wedgwood Collection, Barlaston
(V&A: WE.9373-2014 to WE.9376-2014)

Wedgwood's 'Satsuma' shape was introduced in 1865, inspired by Japanese lacquer and metalwork shapes. The flat-sided design of this teaware range suited it to different styles of decoration, both at Etruria and by outside artists. These examples include the 'Mikado and Landscape' pattern (featuring a 'mazarine' blue glaze and gold design) and a sugar bowl, now missing its lid, featuring a rare early photolithographic design. This reflected the company's ongoing interest in photography, which began with Tom Wedgwood's early experiments with fixing an image.

52. 'The Great Exhibition
1851 – Industry of All Nations:
Etruria & Wedgwood', *Illustrated
Art Catalogue*, 1851
V&A Wedgwood Collection, Barlaston
(V&A Wedgwood Collection Archive)

Despite the financial challenges facing the company after the
death of Josiah Wedgwood II in 1843, the Great Exhibition in
the Crystal Palace, London, in 1851 was seen as an important
moment for it to relaunch itself on the world stage. Wedgwood
displayed a wide range of traditional jasperware, as well as
early examples of Parian ware, a popular statuary porcelain
first put into production by Wedgwood as 'Carrara' in the
late 1840s. Recognizing the importance of this world fair to
contemporary design and manufacture, Wedgwood sent all its
employees to London to view the exhibition, and showcased
their products at subsequent international exhibitions,
including those in Paris, Sydney and Melbourne.

The smooth, vivid colours of majolica became hugely popular after its launch by Minton at the Great Exhibition in 1851. Wedgwood's stand at the exhibition showcased neoclassical jasper, which was by this time no longer at the forefront of ceramic design. Minton and Wedgwood's other competitors responded to 'majolica mania' by producing ranges of lively and colourful majolica ceramics – and generated huge profits. Wedgwood was relatively late to introduce it, partly owing to financial constraints in the 1840s that limited the firm's ability to develop the right glazes, but the introduction of new majolica ranges contributed to Wedgwood's resurgence in the 1860s.

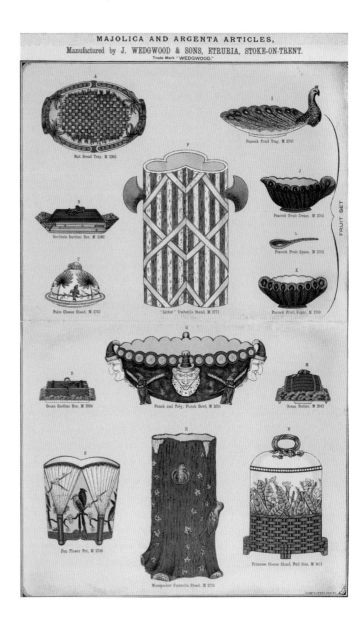

MAJOLICA AND ARGENTA ARTICLES,
Manufactured by J. WEDGWOOD & SONS, ETRURIA, STOKE-ON-TRENT.
Trade Mark "WEDGWOOD."

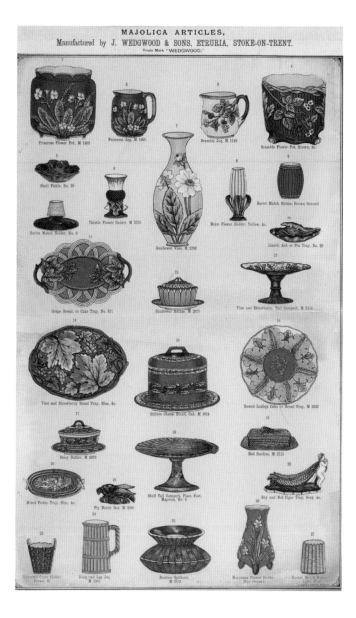

53. Printed advertisement for
majolica and Argenta ware, c.1880s
V&A Wedgwood Collection, Barlaston
(V&A: WE.139-2014)

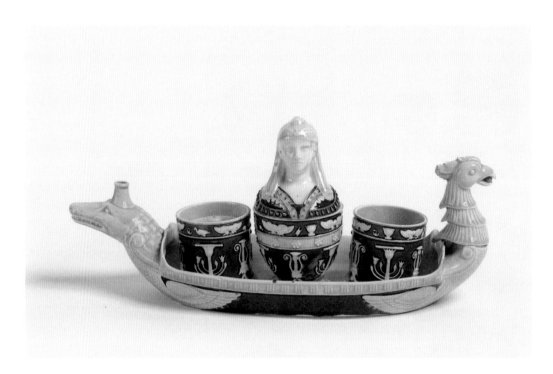

54. Egyptian-style desk set, 1875
Queen's ware with majolica glazes
V&A Wedgwood Collection, Barlaston
(V&A: WE.10003-2014)

55. Helmet ewer, 1885
Queen's ware with majolica glazes
V&A Wedgwood Collection, Barlaston
(V&A: WE.10004-2014)

Wedgwood initially revived many of its existing neoclassical shapes, such as this Egyptian-style inkstand in colourful majolica lead glazes.[32] The company also engaged leading artists, including the French potter Joseph-Théodore Deck (1823–1891), the French sculptor Albert-Ernest Carrier-Belleuse (1824–1887) and Christopher Dresser (1834–1904; **63–4**), to create new majolica designs, often in several colourways. This gilded table centrepiece in the form of Minerva's helmet, available in nine colours, could be stood on its back to be used as a jug. Responding to changes in taste, Wedgwood went on to introduce Argenta ware, a majolica range with more muted, silvery colours.

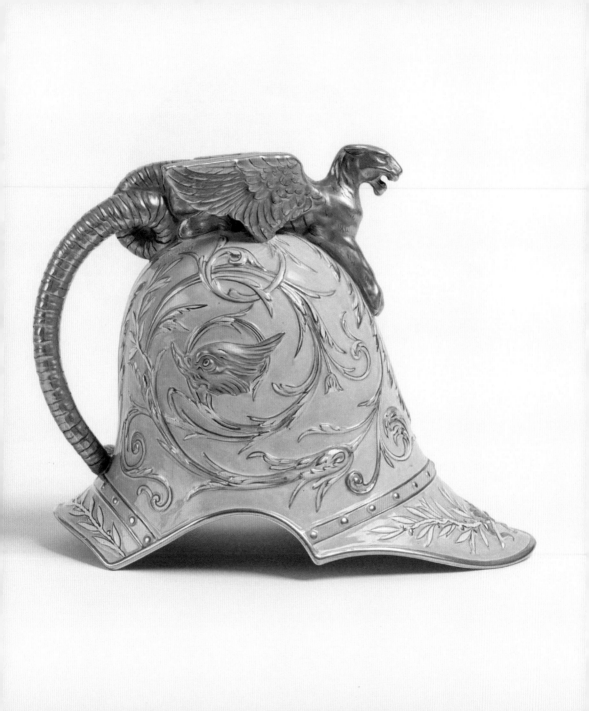

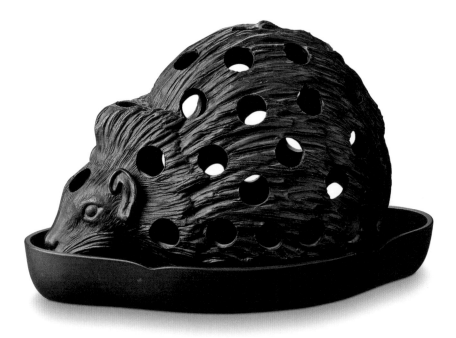

56. Bulb pot and stand in the shape of a hedgehog, *c.*1920s
Black basalt
V&A Wedgwood Collection, Barlaston
(V&A: WE.8223-2014)

During the eighteenth century Josiah Wedgwood catered to the enormous market for garden ware and flowerpots, for use both inside the home and outdoors. New productions included traditionally shaped plant pots to suit a range of garden sizes, budgets and tastes, and the more whimsical, such as this hedgehog-shaped bulb pot. Described in the Oven Books of the period as 'porkepins & stands for snodrips', it was designed to be filled with soil and planted with bulbs such as snowdrops or crocuses, which, once grown, would resemble the spines of a hedgehog.[33]

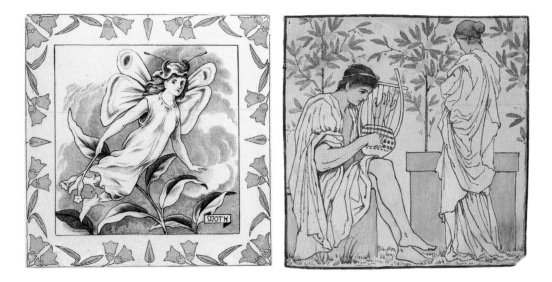

In about 1875 Thomas Allen (1831–1915), an employee of long standing at Minton and a former pupil of Minton's Art Pottery Studio in South Kensington, moved to Wedgwood, where he reinvigorated the design studios, creating links to art schools, training artists and introducing new machinery. He adapted many existing designs with modern technology, such as block-printing presses, which allowed Wedgwood to produce tiles that could be embellished with enamel hand-painting or the addition of borders. Allen introduced his own designs, new techniques and new artists, including Helen J.A. Miles (fl.1867–1907), whose tiles inspired by the works of Shakespeare were very popular.

Alongside transfer-decorated tiles and art tiles, Wedgwood produced a range of architectural tiles. These included tiles for pavements, walls and dados, as well as for fireplaces, as illustrated in the catalogue shown here. They reflect the demand in the Victorian period for flamboyant but also practical interiors. In production from 1875, tiles were a relatively short-lived venture for the Etruria factory. Economic problems in the industry and tighter government legislation on the use of lead glazes resulted in the closure of the tile department in 1902, when the company sold off its stock and tile-manufacturing equipment.[34]

58. Designs for wall decoration in enamelled tiles, nos 307a, 308a, 309a, 310a, 311a, 312a, 1880 from *Josiah Wedgwood & Sons: Manufacturers of Encaustic Tiles and Mosaic Pavements; Tiles for Heaths, Jambs & Wall Decoration, Handpainted, Majolica, Printed, Embossed, Enamelled & Plain Glazed Tiles of Every Description*, 1880
V&A Wedgwood Collection, Barlaston
(V&A Wedgwood Collection Archive: E47-29358a)

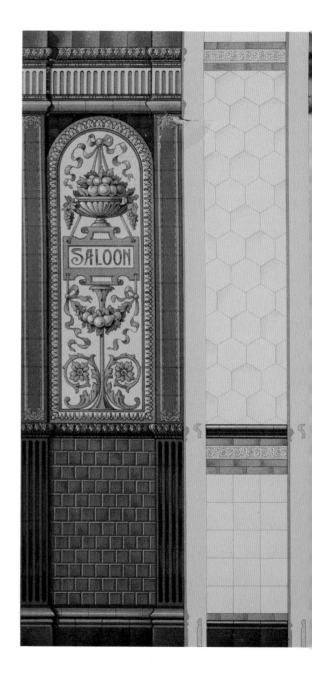

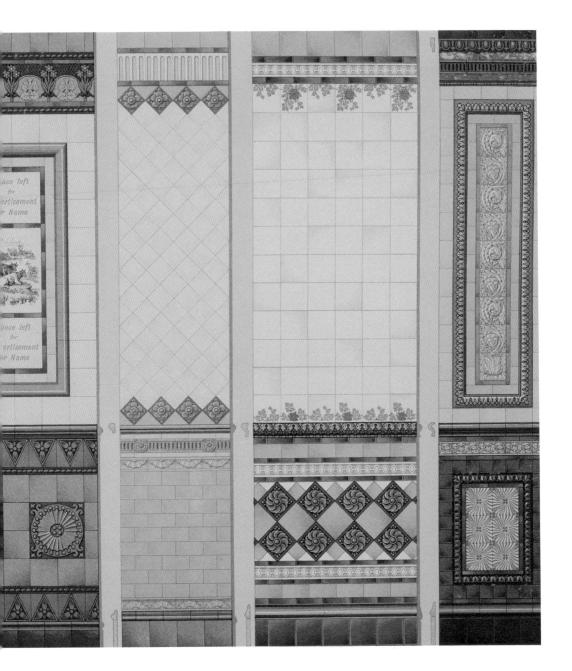

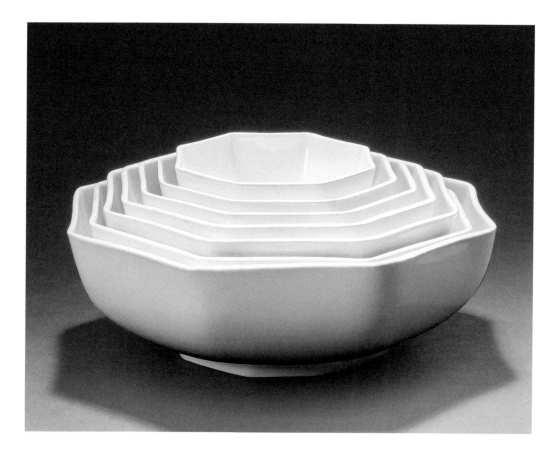

59. Stacking dishes, 1810–30
Queen's ware
V&A Wedgwood Collection, Barlaston
(V&A: WE.8551-2014)

60. Stacking meat carriers
with base and cover, c.1820
Queen's ware
V&A Wedgwood Collection, Barlaston
(V&A: WE.8550-2014)

Utilitarian tableware and kitchenware remained a staple
of Wedgwood's output during the nineteenth century. Queen's
ware continued to prove itself a versatile and durable ceramic
body, suited to a wide variety of practical uses in the kitchen.
Besides decorative pieces for the dining room, meat carriers,
stacking bowls – available in octagonal, diamond, circular
and scalloped shapes – pudding moulds, bin labels, weights and
ceramic inserts for saucepans were manufactured at this time.

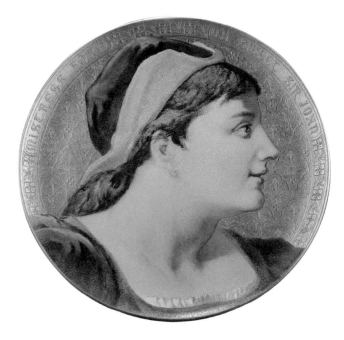

61. Thomas Allen, 'Mistress
Ford' plaque, 1881
Queen's ware with gold paste decoration
V&A Wedgwood Collection, Barlaston
(V&A: WE.9106-2014)

Thomas Allen's (57) earthenware wall plaques with raised
gold paste decoration are among his most impressive designs
for Wedgwood, demonstrating his considerable skill as a
ceramic artist. Allen took inspiration from some of the greatest
works in English literature, from the plays of Shakespeare
to Sir Walter Scott's *Ivanhoe* (1819). Of the characters from
Shakespeare, eight subjects have been identified: Mistress Ford,
Sir John Falstaff, Romeo, Juliet, Othello, Desdemona, Jessica
and Petruchio. Plaques like this appealed to the late Victorian
public, who were attracted by romantic heroes and heroines
in a revival of the past, perhaps driven by the speed of change
at the time.

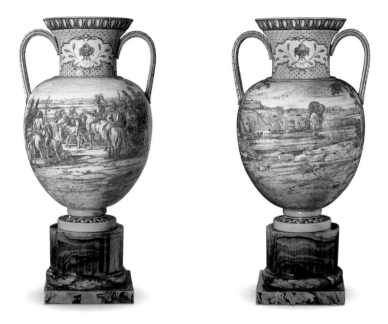

62. Monumental vase (front and back
view) painted by Emile Lessore, 1863
Queen's ware
V&A Wedgwood Collection, Barlaston
(V&A: WE.9245-2014)

The French artist Emile Lessore (1805–1876) was a genre
painter before he discovered ceramic decoration. He worked
at Sèvres and Minton before approaching Wedgwood in 1860,
where he carried out a series of experiments with Clement
Francis Wedgwood to re-create the effect of Italian Renaissance
maiolica painting (tin-glazed earthenware). Thought to be
the largest objects made at Wedgwood, this monumental vase
and its pair at the Birmingham Museum of Art, Alabama, are
decorated with a scene after the French painter Charles Le Brun
(1619–1690), from his 'Triumphs of Alexander' cycle. The exact
circumstances of their commission remain unknown, but factory
records include Lessore's account book of 1863, noting the
decoration of a large pair of vases at £24.

63. Christopher Dresser, 7883 and 7884
Cottage Border, Eighth Wedgwood
Pattern Book, 1860s
V&A Wedgwood Collection, Barlaston
(V&A Wedgwood Collection Archive:
E62-33292)

64. Christopher Dresser, pair of
spill vases, 1867
Queen's ware with printed and
gilded decoration
V&A Wedgwood Collection, Barlaston
(V&A: WE.9249-2014 and WE.9250-2014)

The Scottish designer Christopher Dresser was part of the Arts and Crafts movement. Inspired by Japanese art, he adopted stylized rather than naturalistic motifs. Dresser was closely engaged with industrial production, creating many designs for the textile, metalworking and ceramics industries, including Minton as well as Wedgwood. Working for Wedgwood from the 1860s onwards, he produced a number of majolica designs, and his patterns were applied to a variety of and ornamental and tablewares. His design for this printed and gilded pair of spill jars (to contain tapers or 'spills' for lighting fires) was patented by Wedgwood in 1867.

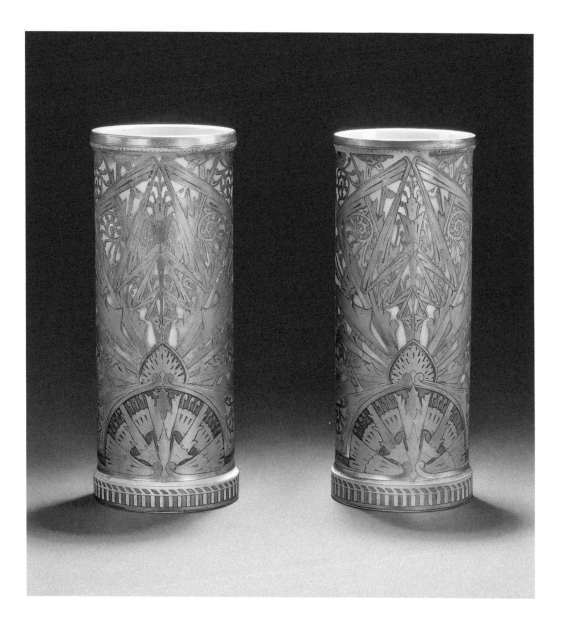

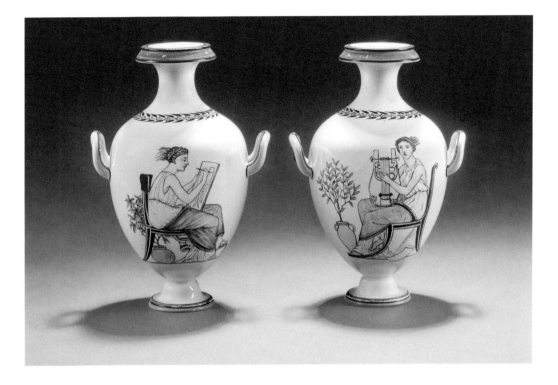

65. Walter Crane, pair of vases, 1862
Queen's ware
V&A Wedgwood Collection, Barlaston
(V&A: WE.9246-2014 and WE.9247-2014)

Like Dresser (63–4), the artist, designer and book illustrator
Walter Crane (1845–1915) was a leading figure in the Arts
and Crafts movement. Crane's first project for Wedgwood was
a series of monochrome designs for Queen's ware vases, with
themes including the Seasons, the Hours and the Ages of Man.
He later produced a series of polychrome patterns, including
this pair of vases decorated with emblems of painting and
music. A number of Crane's painted vases were shown at the
Paris Exhibition of 1867, and although he produced a number
of other designs for plaques and centrepieces, not all were
put into production.

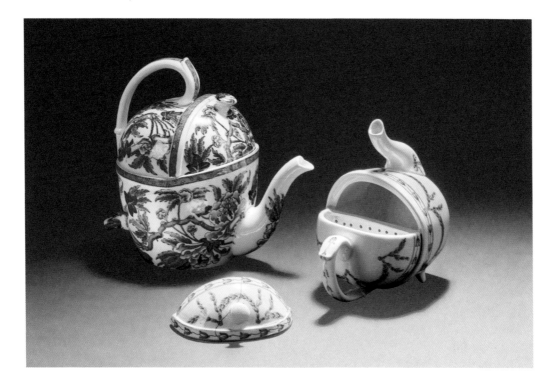

As tea became ever more popular, Wedgwood continued
to experiment with new teaware. The 'SYP' – standing for
Simple Yet Perfect – teapot was patented by Sir Douglas Baillie
Hamilton Cochrane in 1901. Wedgwood produced a Queen's
ware version from 1906/7 in various patterns from 'Peony',
first introduced in 1806, to 'Oaklands'. The 'SYP' design had
special feet to allow it to be stood on its back for brewing; when
the pot was placed upright, a divider held the leaves away from
the water to prevent the tea from stewing.

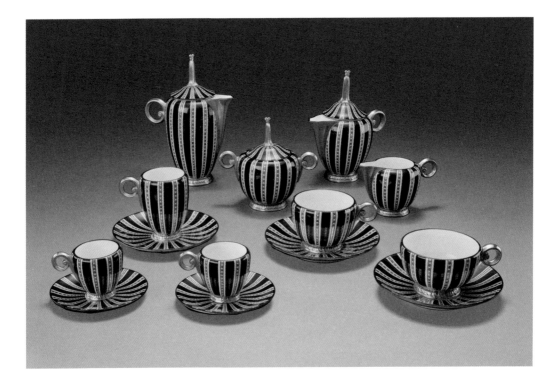

67. Paul Follot for Josiah
Wedgwood & Sons, tea and coffee
set, 'Campanula' shape, *c.*1923
Bone china
V&A Wedgwood Collection, Barlaston
(V&A: WE.26-2021 to 29-2021, WE.31-2021,
WE.34-2021, WE.38-2021, WE.42-2021 and
WE.43-2021)

68. Paul Follot, design drawing
for 'Campanula' cafetière, *c.*1923
Pencil on paper
V&A Wedgwood Collection, Barlaston
(V&A Wedgwood Collection Archive:
WE/PF/1/1)

Paul Follot (1877–1941) was a French designer of luxury
furniture and decorative art objects, and director of the
Pomona Studios at the Paris department store Le Bon Marché.
In 1911 he was commissioned by Cecil Wedgwood (1893–1916)
to produce a series of Art Deco shape designs for Wedgwood.
Their production was delayed by the outbreak of World War I,
and they were made only in small quantities in the early 1920s,
their elaborate form and decoration making them very labour-
intensive to produce. This rare 'Campanula' tea and coffee set
was formerly in the collection of Karl Lagerfeld (1933–2019),
creative director of the Paris fashion house Chanel.

WEDGWOOD "CAMPANULA"

CAFETIÈRE

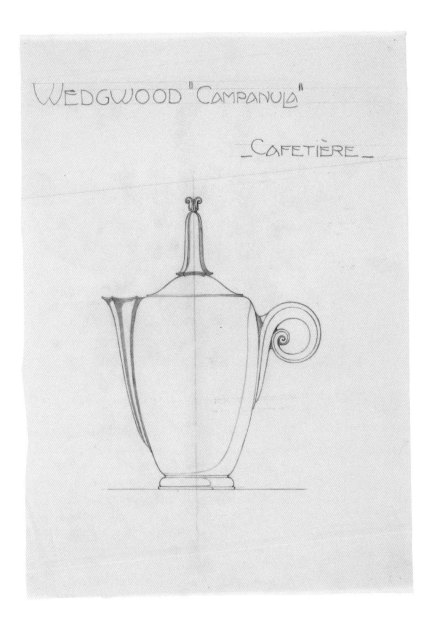

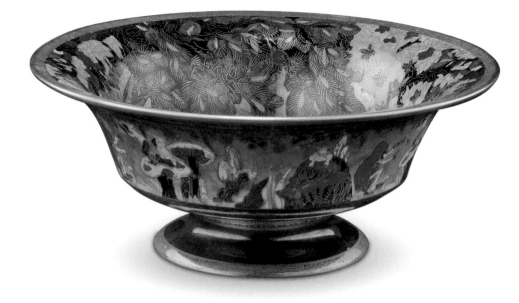

69. Daisy Makeig-Jones, 'Fairyland'
lustre chalice bowl, 1923
Bone china with painted, gilded and
lustre decoration
V&A Wedgwood Collection, Barlaston
(V&A: WE.9652-2014)

70. Etruria catalogue featuring
designs for 'Fairyland' lustre, c.1920
V&A Wedgwood Collection, Barlaston
(V&A Wedgwood Collection Archive)

Susannah Margaretta Makeig-Jones (1881–1945), known
as Daisy, joined the Wedgwood factory in 1909 as a trainee
painter, going on to design tablewares and 'Ordinary'
lustreware ranges decorated with dragons, butterflies and
hummingbirds. Her 'Fairyland' lustre ranges were produced
from 1915 until 1931. Combining the rich sheen of metallic
glazes with elaborate and fanciful motifs and gold-printed
designs, 'Fairyland' lustre was hugely popular during the 1920s,
but gradually went out of fashion. Makeig-Jones featured in
Josiah Wedgwood's Bicentenary pageant (fig. 17) dressed as
'Sybil', one of Wedgwood's iconic finial designs, surrounded
by 'paintresses' dressed as 'Portland Vases'.

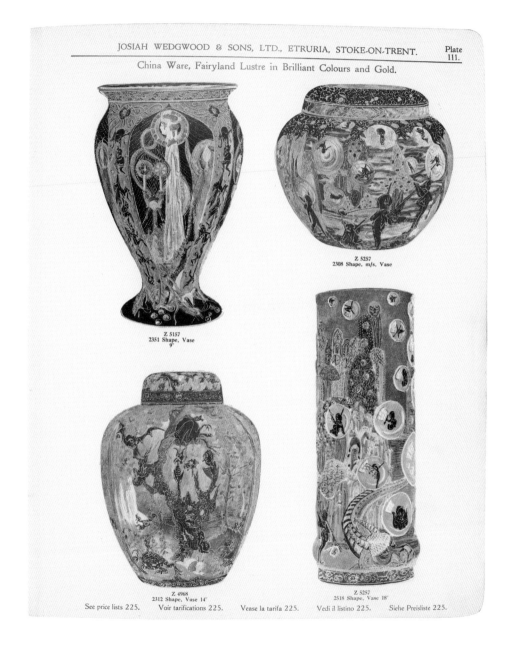

China Ware, Fairyland Lustre in Brilliant Colours and Gold.

Z 5157
2351 Shape, Vase
9"

Z 5257
2308 Shape, m/s, Vase

Z 4968
2312 Shape, Vase 14"

Z 5257
2518 Shape, Vase 18"

See price lists 225. Voir tarifications 225. Vease la tarifa 225. Vedi il listino 225. Siehe Preisliste 225.

71. Scalloped-edge bowl painted
by Millicent Taplin, 1922
Queen's ware painted in lustre
V&A Wedgwood Collection, Barlaston
(V&A: WE.9534-2014)

The pioneering Stoke-on-Trent 'paintress' Millicent Taplin
(1902–1980) was trained by Alfred and Louise Powell in
the small handcraft department at Etruria. Having joined
Wedgwood in 1917, she set up the 'hand crafts' studio in 1926;
it merged with the hand-painting department a year later,
and she began to design her own free-flowing, naturalistic
patterns in 1928. Taplin taught later at Stoke School of Art and
Burslem School of Art, and frequently collaborated with Victor
Skellern (76) on projects from the introduction of lithographic
printing, which enabled Wedgwood to reproduce colourful
and complex designs and remains in use today, to the creation
of new designs. Most notable of these was 'Strawberry Hill',
which received a Design of the Year Award from the Council
of Industrial Design in 1957.

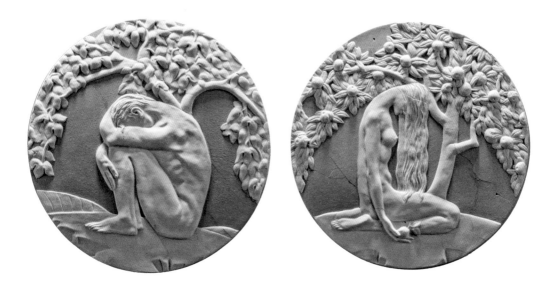

While Wedgwood continued to produce many of its traditional eighteenth-century jasper designs, new styles heralded a more modern approach. The 'Adam' and 'Eve' plaques, modelled by Anna Zinkeisen (1901–1976), were awarded a silver medal at the Paris Exhibition of 1925. Wedgwood began to commission Zinkeisen while she was still a student at the Royal Academy Schools. These plaques and her other designs, 'Sun' and 'Wind', capture the nascent Art Deco style in jasper, and were produced in blue and white, black and white, and green and white.

During their association with Wedgwood, husband-and-wife artists Alfred Powell (1865–1960) and Louise Powell (1882–1956, the granddaughter of Emile Lessore; 62) reforged the company's links with art pottery. Alfred had originally trained as an architect, and Louise as a calligrapher, and these disciplines informed their pottery designs. Inspired by Wedgwood's early pattern books, around 1906 the Powells established a school of freehand 'Paintresses', creating new ranges of hand-painted ceramic designs. Wedgwood also supplied undecorated pieces for the Powells to decorate in their London studio. Many of Wedgwood's most distinctive ceramics from this period bear Alfred's or Louise's monogram.

73. Wall plaque depicting a deer, painted by Alfred Powell, 1920
Queen's ware
V&A Wedgwood Collection, Barlaston
(V&A: WE.9490-2014)

74. Alfred Powell decorating a bowl, mid-20th century
Photograph
V&A Wedgwood Collection, Barlaston
(V&A Wedgwood Collection Archive: B/FR 4350)

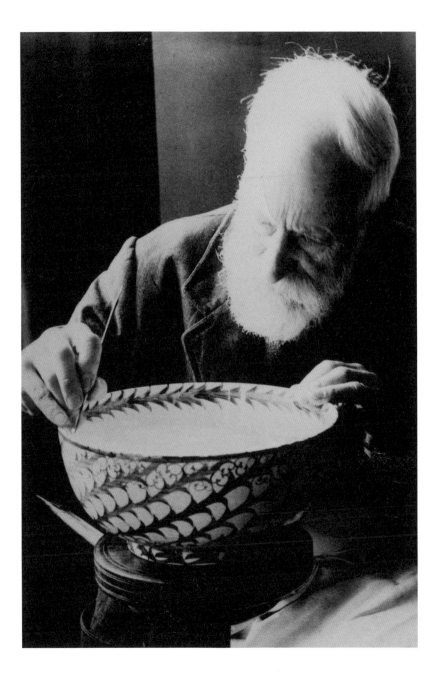

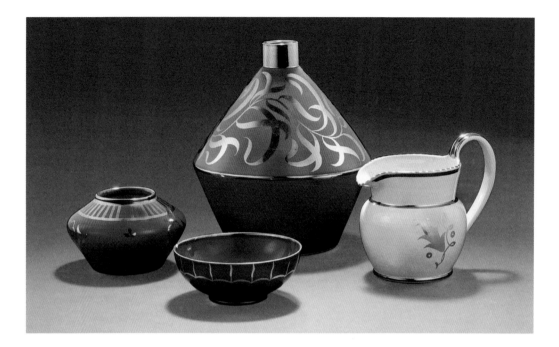

75. Selection of 'Veronese' ware, 1930s
Queen's ware with lustre decoration
V&A Wedgwood Collection, Barlaston
(V&A: WE.9596-2014 to WE.9599-2014)

The Powells' influence on Wedgwood, particularly with the
reintroduction of free-hand-painted design traditions and
flowing lustre patterns, lasted for well over four decades.
Their style influenced their pupils, most notably Millicent
Taplin (71). 'Veronese' ware was introduced in the early 1930s,
combining hand-painting with newly developed matte and
lustre glazes. A new wave of Wedgwood designers and artists
joined the company, including Norman Wilson (1902–1985;
79–80, 83–4, 90), Victor Skellern (1909–1966; fig. 15, 76) and
the architect Keith Murray (1892–1981; 81–2, 89), and were
instrumental in pushing the company towards new territory.

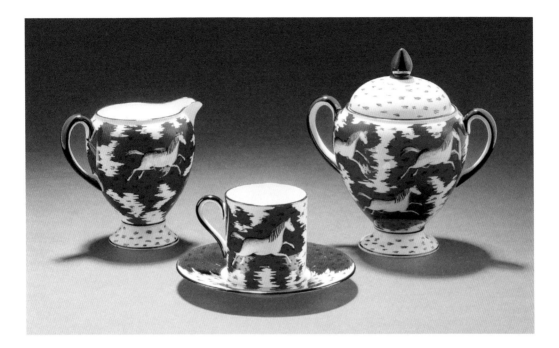

76. 'Persian Ponies' tea set, 1934
Bone china
V&A Wedgwood Collection, Barlaston
(V&A: WE.9772-2014 to WE.9774-2014)

As Wedgwood began to bring a more modernist approach to its ornamental wares, tableware design was undergoing its own transformation under the new art director, Victor Skellern, who joined in 1923 as the first fully trained professional designer to be employed by the company. Skellern had studied at Burslem School of Art and in 1930 took up a scholarship at the Royal College of Art. He returned to Wedgwood in 1934, and went on to engage many freelance artists to produce new designs and patterns, including Edward Bawden (1903–1989), Clare Leighton (1898–1989), Eric Ravilious (1903–1942; 85–8), Laura Knight (1877–1970) and Rex Whistler (1905–1944). Skellern's own designs included the patterns 'Wild Oats' and 'Persian Ponies', and black-basalt and jasper vase shapes.

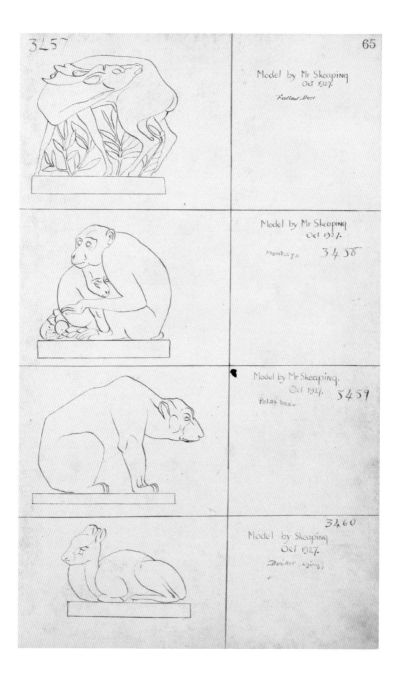

Model by Mr Skeaping
Oct 1927.
Fallow Deer

Model by Mr Skeaping
Oct 1927.
Monkeys 3458

Model by Mr Skeaping.
Oct 1927. 3459
Polar bear

3460
Model by Skeaping
Oct 1927.
Duiker lying

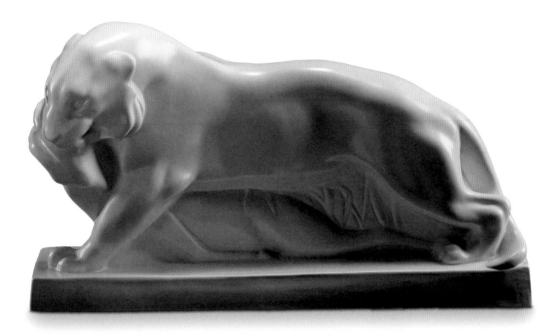

77. John Skeaping, designs in
Wedgwood Shape Book, 1927
Pencil on paper
V&A Wedgwood Collection, Barlaston
(V&A Wedgwood Collection Archive:
E54-30019h)

78. John Skeaping, 'Tiger with Buck',
c.1935
Queen's ware with a matte glaze
V&A Wedgwood Collection, Barlaston
(V&A: WE.9533-2014)

In 1924 the sculptor John Skeaping (1901–1980) won the
prestigious Prix de Rome, and while studying in Italy he met
and married the artist Barbara Hepworth (1903–1975), whose
work would have a profound impact on his own sculptural style.
In 1927 he was commissioned by Francis (Frank) Wedgwood
(1867–1930) to produce a series of 14 animal studies for
Wedgwood, 10 of which were produced in black basalt and
a variety of modern matte glazes, including 'Polar Bear', 'Fallow
Deer' and 'Monkeys'. Skeaping's designs for Wedgwood were
a key decorative feature of the cabins on RMS *Queen Mary*
(launched in 1936), their modernity in keeping with the
stylish interior of the new ocean liner.

79. Display of Wedgwood ware
at Grafton Street Gallery, 1936
V&A Wedgwood Collection, Barlaston
(V&A Wedgwood Collection Archive:
B/FR 87)

80. 'Alpine Pink' nautilus dish, 1936
Bone china
V&A Wedgwood Collection, Barlaston
(V&A: WE.9663-2014)

In the 1930s a number of additions were made to Wedgwood's range of ceramic bodies and glazes, pioneered by Norman Wilson, initially the works manager but later production director and finally managing director of the company. The launch of 'Alpine Pink', a colour in keeping with the latest trend for pastel tones, was heralded as the key innovation in an exhibition of new Wedgwood designs at the Grafton Galleries, London, in 1936. This exhibition also included the launch of new ranges by Louise Powell (73–4) and the hand-painting studio. Some of the 'Alpine Pink' products, such as the shell tureen, were reissued eighteenth-century Wedgwood designs, transformed by the new colour.

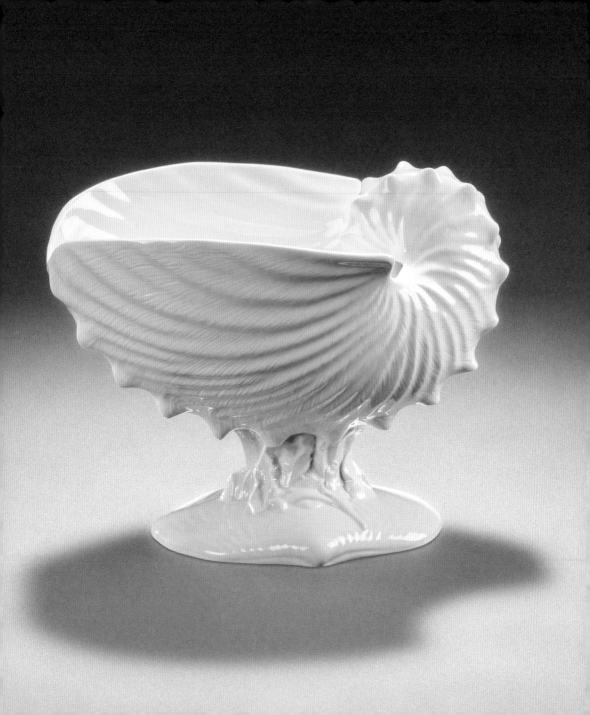

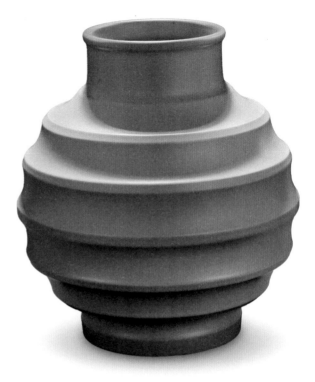

81. Keith Murray, 'Shape 3802' vase, 1935
Earthenware with matte green glaze
V&A Wedgwood Collection, Barlaston
(V&A: WE.9670-2014)

82. Watercolour drawings
of Keith Murray designs, 1930s
Watercolour on paper
V&A Wedgwood Collection, Barlaston
(V&A: WoP 4719, WoP 4726, WoP 4728,
WoP 4722, WoP 4725, WoP 4721, WoP
4729, WoP 4720 and WoP 4727)

Originally trained as an architect, Keith Murray designed
Wedgwood's factory building at Barlaston, which opened
in 1940, but his initial involvement with Wedgwood was as
a ceramics designer.[35] Between 1932 and 1939 Murray created
more than 1,200 designs for Wedgwood, including shapes and
hand-painted border patterns, characterized by their simple,
clean forms and effective use of the company's new matte
glazes. Murray reimagined Wedgwood's traditions with
a modern aesthetic, from its iconic clay bodies, black basalt
and Queen's ware, to its decorating techniques, particularly
lathe-turning and ribbing to create two-tone effects.

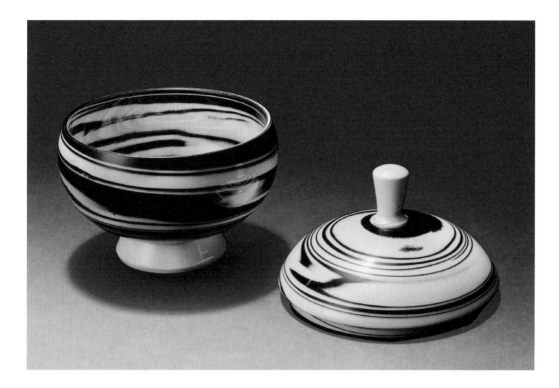

83. Display of Wedgwood Ware
at Grafton Galleries, 1936
V&A Wedgwood Collection, Barlaston
(V&A Wedgwood Collection Archive:
B/FR 87)

84. Norman Wilson, 'Unique Ware'
powder bowl, *c.*1962
Bone china with agateware decoration
V&A Wedgwood Collection, Barlaston
(V&A: WE.4226–2014)

Wilson introduced a series of 'Unique' ranges that
brought studio pottery techniques into the factory. His
designs incorporated 'glazes from special recipes. These
are experimental pieces which Messrs Wedgwood cannot
undertake to repeat.'[36] Produced in small numbers and not
sold in Wedgwood's shops, many of the pieces combined
modern glazes and forms with reinterpretations of classic
Wedgwood decoration, from agateware to incised banding
and turning. They were shown in 1936 in the Grafton Galleries
exhibition, which proved an important launchpad for some
of Wedgwood's most modern developments.

b. L. 6323. C. C. Garden implements printed in sepia. painted in 208 L
purple lustre & 84 pink lustre. Lined in black.

Jug. See back of Jug on
next page.

Print on
handle of
Jug.

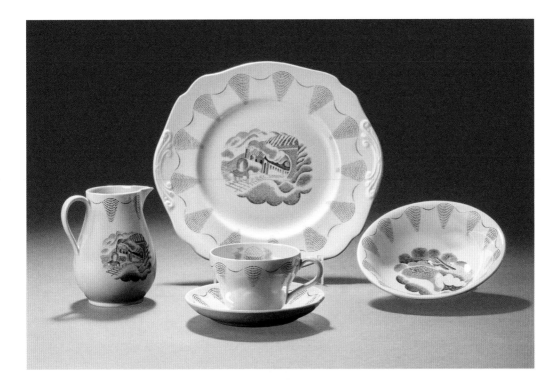

85. Eric Ravilious, 'Garden Implements painted in sepia' pattern for a Liverpool jug, C11 Pattern Book, 1930s
V&A Wedgwood Collection, Barlaston
(V&A Wedgwood Collection Archive: E62-33529)

86. Eric Ravilious, 'Travel' platter, milk jug, teacup and saucer and bowl, c.1953
Queen's ware
V&A Wedgwood Collection, Barlaston
(V&A: WE.5-2021, WE.24-2021, WE.12-2021 and WE.18-2021)

The British artist Eric Ravilious produced designs for Wedgwood for a short period from 1936. The company continued to produce many of his designs after his untimely death as a war artist in 1944, and they remained enduringly popular and associated with the brand. His first design was the commemorative mug made for the coronation of King Edward VIII, hastily adapted for King George V after the abdication, and later manufactured for Queen Elizabeth II's coronation. 'Travel', a pattern adorned with trains, boats and hot-air balloons, was designed in 1938 but produced only once wartime restrictions were lifted in the 1950s on a new Queen's ware colour, 'Windsor Grey'.

87. Eric Ravilious, 'Alphabet' mug, 1937
Queen's ware
V&A Wedgwood Collection, Barlaston
(V&A: WE.9786-2014)

88. Eric Ravilious, 'Alphabet Pattern
printed in sepia' pattern, C11
Pattern Book, 1930s
V&A Wedgwood Collection, Barlaston
(V&A Wedgwood Collection Archive:
E62-33529)

Eric Ravilious's watercolours and engravings proved
an excellent match with Wedgwood's Queen's ware. His
'Alphabet' nursery designs were among the most popular,
uniting simple colourways with a playful, appealing pattern.
Ravilious was interested in Wedgwood's design process, and
was initially concerned that the transfer-printing technique
would cause the essence of his designs to be lost. Victor
Skellern wrote that on seeing the work of Wedgwood's skilled
team, Ravilious said, 'these chaps are without doubt the finest
engravers I have ever met.'[37]

YZ

B C D E F G H I J K L

M N O P Q R S T U V W X

mug 4169 ⁴/5

A B C D E F G H I J K L

M N O P Q R S T U V W X

mug

mug 4169. 36²

DESIGNS BY **KEITH MURRAY**, AND
ANIMAL FIGURES BY **JOHN R. SKEAPING**
IN **WEDGWOOD**

Advertising was as important to the Wedgwood story as were
its ceramics. Wedgwood created modern visuals, placing the
wares in the context of potential customers' homes. Taglines
such as 'a living tradition' highlighted the firm's ambition to
remain connected to its prestigious history even as it created
up-to-the-minute designs and introduced new ceramic bodies,
glazes and forms, and collaborated with contemporary artists.
This advertisement shows popular modern ranges created
in collaboration with John Skeaping and Keith Murray.

This streamlined design in Queen's ware was created by
Norman Wilson to mark the move of the Wedgwood factory
from Etruria to Barlaston. It went into production in 1955,
following delays in restarting full production after the end of
World War II. Different coloured bodies were combined with a
clear glaze on the 'Barlaston' shape to achieve a two-tone effect
in green, blue, brown or grey. This range reflected Wilson's
ongoing interest in technical and glaze experiments and other
improvements to production techniques. As production manager
he introduced new tunnel kilns at the Barlaston factory, one
of the first electric factories in the United Kingdom.

91. Susie Cooper, 'Pennant'
pattern cups and saucers, 1969
Bone china
'V&A Wedgwood Collection, Barlaston
(V&A: WE.4068-2014 to WE.4073-2014)

Susie Cooper (1902–1995) began designing for Wedgwood
in 1966, when her company was acquired by the Wedgwood
Group. A pioneering female business-owner, Cooper was also
a Royal Designer for Industry. She created iconic patterns from
'Carnaby Daisy' (1968) to 'Cornpoppy' (1971), and combined
stylized motifs, often using her own shapes, as in this example,
with bold colours to create mismatched 'harlequin' sets.
Wedgwood expanded significantly between the 1960s and the
80s, acquiring William Adams (1966), Coalport and Johnson
Brothers (1968), Mason's Ironstone (1973) and other well-
known ceramics firms.

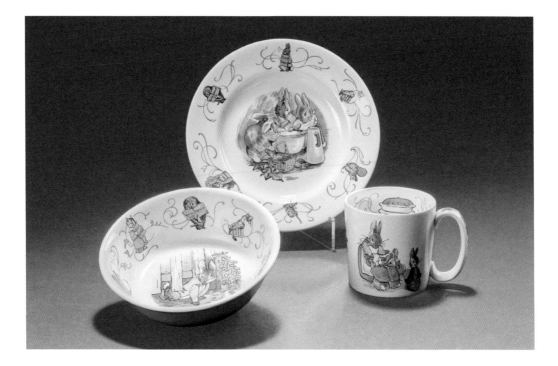

92. Peter Rabbit nurseryware, *c.*1965
Queen's ware with colour lithography
V&A Wedgwood Collection, Barlaston
(V&A: WE.4074-2014 to WE.4076-2014)

From 1949 Wedgwood manufactured Peter Rabbit nurseryware under licence from Beatrix Potter's publisher, Frederick Warne & Co. Between 1981 and 2003 Wedgwood produced annual seasonal giftware printed with Peter Rabbit and other characters created by Beatrix Potter (1866–1943). Wedgwood's playful designs captured the essence of Potter's famous illustrations, and as the plates, bowls and mugs sold well, the range was expanded to include blue-and-white jasper plates, pencil pots and egg-shaped boxes. Children's ranges, from Daisy Makeig-Jones's 'Cobble and Zoo' and 'Noah's Ark' to 'Big Top' designed by Peter Wall, to Eric Ravilious's 'Alphabet', were an important market for the company.

Wedgwood's refined black-basalt body lent itself as well to modern, textural designs as it had to elaborate eighteenth-century forms. Robert Minkin (1928–2012) joined Wedgwood in 1955 after graduating from the Royal College of Art, and became design director in 1979. He created many distinctive pieces, including new black-basalt shapes for the renowned 'Design 63' exhibition, along with Peter Wall (1926–2018). Keith Murray also created a number of designs with engine-turned decoration that were produced in black basalt.

93. Robert Minkin, 'Design for Today'
vases, 1967
Black basalt and gilt
V&A Wedgwood Collection, Barlaston
(V&A: WE.9986-2014 to WE.9988-2014)

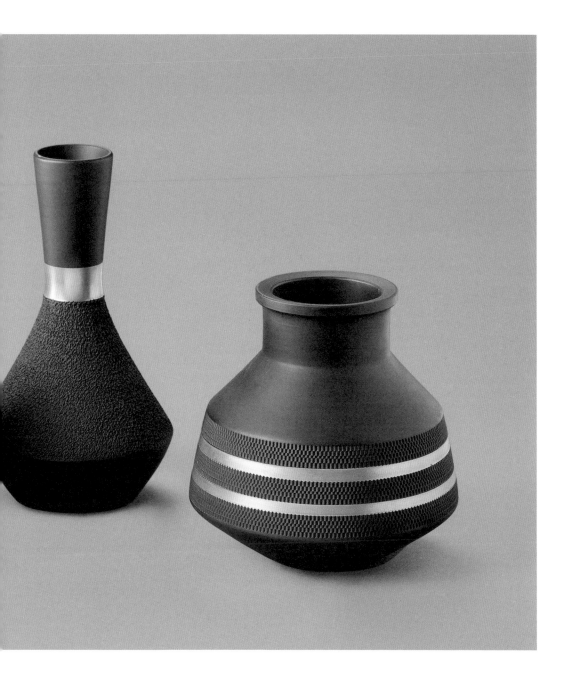

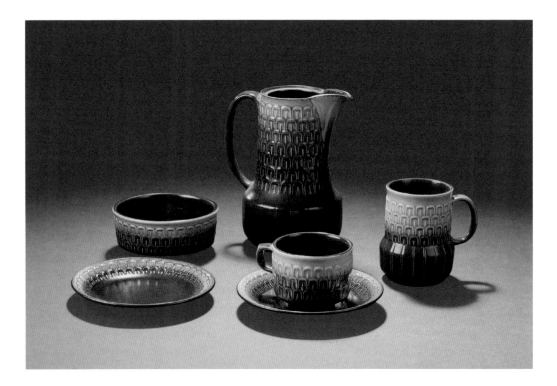

94. Robert Minkin, 'Sierra'
oven to tableware, 1970
Stoneware
V&A Wedgwood Collection, Barlaston
(V&A: WE.9911-2014 to 9915-2014)

95. Magazine advertisement for
'Blue Pacific' oven to tableware
designed by Robert Minkin, 1973
V&A Wedgwood Collection, Barlaston
(V&A Wedgwood Collection Archive:
B/FR 4004)

Minkin oversaw the move to Wedgwood's iconic 'Roundhouse' design studio at Barlaston in 1968. His distinctive tableware patterns introduced simple geometric forms and fashionable colours, including tough 'oven to table' ranges, reflecting more informal ways of living and dining. New products were often accompanied by bold advertising campaigns. This advertisement from 1973 was placed in influential magazines such as *Home and Gardens, Reader's Digest, Vogue, Good Housekeeping, Brides* and *The Observer*.[38] 'Sierra' was produced from 1970 to 1978, while 'Blue Pacific' remained in production from 1968 until 1994.

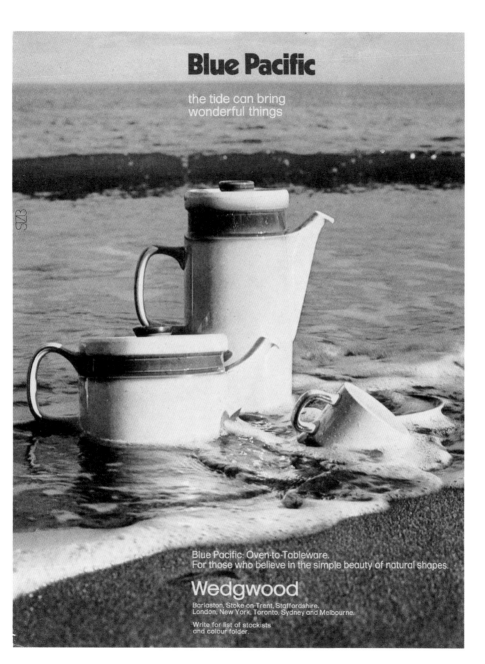

Blue Pacific

the tide can bring
wonderful things

Blue Pacific: Oven-to-Tableware.
For those who believe in the simple beauty of natural shapes.

Wedgwood

Barlaston, Stoke-on-Trent, Staffordshire.
London, New York, Toronto, Sydney and Melbourne.

Write for list of stockists
and colour folder.

96. Eduardo Paolozzi, 'Variations
on a Geometric Theme' plate, c.1970
Transfer-printed on bone china
V&A Wedgwood Collection, Barlaston
(V&A: WE.4271-2014)

97. Eduardo Paolozzi, 'Newton'
figure, 1997
Black basalt
V&A Wedgwood Collection, Barlaston
(V&A: WE.4269-2014)

The Scottish sculptor Eduardo Paolozzi (1924–2005) began
working with Wedgwood in 1970, designing two limited-
edition plate series, 'Variations on a Geometric Theme' and
'Kalkulium Suite', a mug and a black-basalt sculpture of Sir
Isaac Newton (also produced as a large bronze that is now
outside the British Library). The Pop art-inflected 'Variations'
designs were his first ceramics, enabling him to explore
printing as a design tool.[39] Paolozzi was a tutor at the Royal
College of Art, and his design work reflected Wedgwood's
continued links with art schools as a route to design
innovation.

98. Glenys Barton, 'Monte
Alban II', 1976
Bone china
V&A Wedgwood Collection, Barlaston
(V&A: WE.4175-2014)

99. Glenys Barton, 'Head with
Relief Figures', 1976
Bone china
V&A Wedgwood Collection, Barlaston
(V&A: WE.4178-2014)

As Wedgwood's first artist-in-residence from 1976 to 1978,
the pioneering sculptural ceramicist Glenys Barton (b.1944)
worked with the Wedgwood factory to produce a series of
26 sculptures.[40] Using bone china and black basalt, Barton's
sculptures combined the precision of factory techniques, from
transfer-printing to casting, with refined, modern forms.
Her ethereal designs, whose 'subject is always humanity',
explore the human form through the recurring motifs of
figures, silhouettes, heads and hands, prefiguring more
recent sculptural trends.

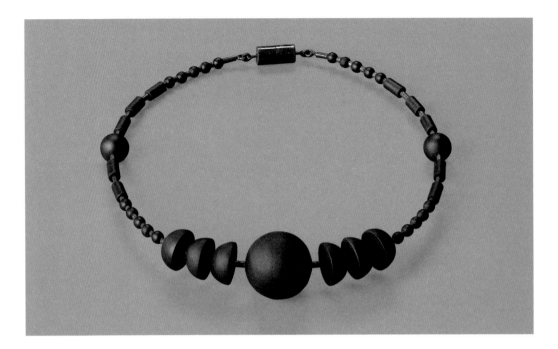

100. Wendy Ramshaw, necklace, 1982
Black basalt
V&A Wedgwood Collection, Barlaston
(V&A: WE.4176-2014)

101. Wendy Ramshaw, 'Three cones'
necklace, 1982
White jasper, gold and silver
Victoria and Albert Museum, London
(V&A: M.81-1982)

'I made approximately 100 drawings for Wedgwood and waited for the beads and shapes to arrive. I soon abandoned the drawings and began working directly with the units, assembling jewellery by trial and error unlike anything I had arrived at through the process of drawing.'[1] The renowned jeweller Wendy Ramshaw (1939–2018) had already begun to experiment with ceramic bodies when she approached Wedgwood. She went on to create a series of jewellery pieces in jasper and black basalt, joining up ceramic elements with precious metals. Wedgwood's factory technology enabled Ramshaw to reach a high level of precision in her ceramic work and to respond to Wedgwood's rich material traditions. The *Wedgwood with Wendy Ramshaw Collection* was shown at the V&A, South Kensington in 1982.

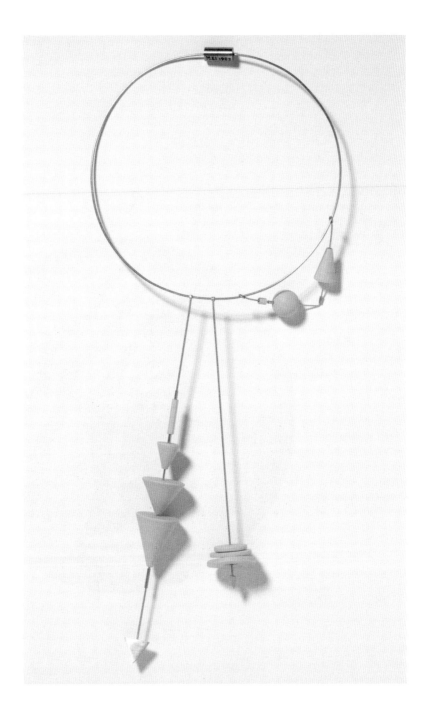

The National Art Collections Fund (now Art Fund) commissioned a series of plates designed by the contemporary artists John Piper (1903–1992), Patrick Caulfield (1936–2005), Patrick Heron (1920–1999), Eduardo Paolozzi (96–7), Peter Blake (b.1932) and Bruce McLean (b.1944). Each plate playfully represented its designer's style using silk-screen printing, enamelling or gilding. The artist's signature appears on the reverse of the plate with the factory mark or backstamp. Blake's design incorporated collaging techniques, while Piper's reflected his interest in the iconography of the folk figure the Green Man in a painterly design.

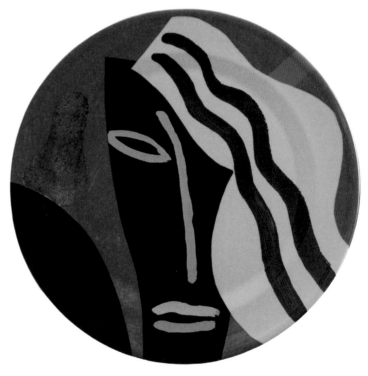

102. 'Passed the Tangerine Test' by Bruce McLean, 'The Green Man' by John Piper, 'Demonstrations' by Peter Blake, 'Fabula' by Eduardo Paolozzi, 'Garden Plate' by Patrick Heron, all 1990
Bone china
V&A Wedgwood Collection, Barlaston
(V&A: WE.4275-2014, WE.4276-2014, WE.4277-2014, WE.4274-2014 and WE.4273-2014)

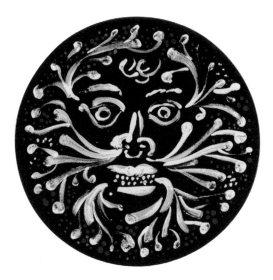

103. Paul Costelloe, pasta plate, 2001
Queen's ware
V&A Wedgwood Collection, Barlaston
(V&A: WE.4278-2014)

Wedgwood continues to collaborate with artists and designers on tableware ranges as well as 'ornamental' and sculptural pieces. The fashion designer Paul Costelloe (b.1945), known best for his work for Diana, Princess of Wales, produced a series of modern Queen's ware designs, bringing this historic material into the twenty-first century. The sculptor Nick Monro (b.1936) – whose range included a Wedgwood dog bowl – created new takes on tableware and black basalt, while the product designer Lee Broom (b.1976) and the artist Hitomi Hosono (b.1978; **fig. 18**) brought new perspectives to Wedgwood's jasper traditions.

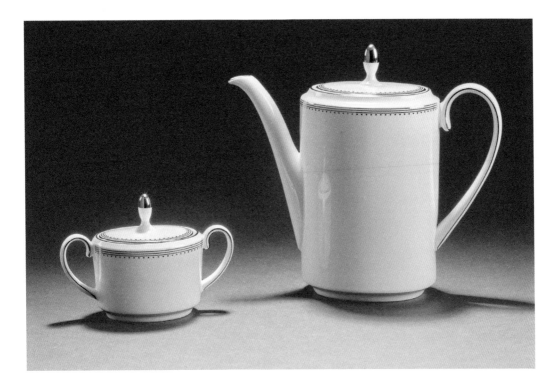

104. Vera Wang, 'Grosgrain'
pattern, 2005
Bone china transfer-printed
with platinum
V&A Wedgwood Collection, Barlaston
(V&A: WE.4364–2014 and WE.4368–2014)

Alongside a strong in-house design tradition, forging
connections with today's artists and designers remains
important to Wedgwood's approach to contemporary
tableware. Collaborations with the hugely successful
American bridalwear designer Vera Wang (b.1949),
beginning in 2002, combined transfer patterns inspired
by textiles with gold or platinum decoration on a range of
ceramics, cutlery, glassware and picture frames. The fashion
designer Jasper Conran (b.1959) created ranges, including
'Strata' and 'Pin Stripe', that were adaptable to more
informal or 'mix-and-match' dining trends.

Notes

Unless otherwise specified, museum numbers given in the notes refer to items held in the V&A Wedgwood Collection Archive, Barlaston.

INTRODUCTION

1. J.W. to Thomas Bentley, 1 October 1769, E25-18264
2. J.W. to Thomas Bentley, February 1769 (no precise date), E25-18232
3. 'The Right Hon. The Chancellor of the Exchequer & Earl Granville in the Potteries: The Wedgwood Institute', *Evening Star*, 27 October 1863, WM 1873
4. Eliza Meteyard, *The Life of Josiah Wedgwood*, 2 vols (London 1865, 1866); Samuel Smiles, *Josiah Wedgwood F.R.S: His Personal History* (London 1894)
5. Robin Reilly, *Wedgwood* (London 1992), p. 3
6. Wedgwood Experiment Book, E26-19117
7. Wedgwood Experiment Book, E26-19115
8. J.W. to John Wedgwood, postmarked 17 June 1765, E25-18073
9. J.W. to Thomas Bentley, September 1769 (no precise date), E25-18256
10. Harwood A. Johnson, 'Books Belonging to Wedgwood and Bentley the 10 Augt 1770', *Ars Ceramica*, 7 (1990)
11. Neil McKendrick, 'Josiah Wedgwood and Factory Discipline', *Historical Journal*, vol. 4, no. 1 (1961), pp. 30–55
12. At the time of writing, the company's association with Etruria has finally come to an end with the closure of the Wedgwood outlet there and renewed focus on the Barlaston site.
13. J.W. to Thomas Bentley, 2 January 1765, E25-18058

PLATES

1. J.W. to John Wedgwood, postmarked 17 June 1765, E25-18073
2. J.W. to his brother John, undated, 'The ordr came from Miss Deborah, alias Deb Chetwynd sempstress, & Laundress to the Queen, to Mr Smallwd of Newcastle, who brot it to me (I believe because nobody else wod undertake it)', E25-18073
3. Ibid.: 'I have just begun an Enamel work & am in great want of some gold powder such is burnt in on China. It is made by one Mr Shenton (only) and sold by him at 7 guineas Per oz, ... I shod be glad to have a few pennywts by way of a trial.'
4. See Patricia F. Ferguson, *Garnitures: Vase Sets from National Trust Houses* (London 2016)
5. J.W. to Thomas Bentley, February 1769 (no precise date), E25-18232
6. E50-29994c
7. British Museum, 1772,0320.15.+
8. 'Catalogue of Cameos, Intaglios,Medals, Busts and Small Statues...'1787, E50-29994c, p. 63
9. Two at the V&A Wedgwood Collection, Barlaston, one at the Potteries Museum & Art Gallery. The final example is at the British Museum on long-term loan from the Wedgwood family.
10. J.W. to Thomas Bentley, probably about September 1767 (no precise date), E25-18167
11. J.W. to Thomas Bentley, 12 December 1774, E25-18572
12. J.W. to Thomas Bentley, 6 August 1779, E26-18914
13. J.W. to Thomas Bentley, 29 April 1770, E25-18297
14. J.W. to Thomas Bentley, 23 March 1773, E25-18450

15. E32-21497a

16. 15 July 1773, E32-24198

17. 2 July 1776, E25-18679

18. 1 March 1779, E26-18880

19. J.W. to Sir William Hamilton, 24 June 1786, E26-18976

20. British Museum 1786,0527.1. See Aileen Dawson, *Masterpieces of Wedgwood in the British Museum* (London 1984)

21. Josiah Wedgwood and Thomas Bentley, *A Catalogue of Cameos, Intaglios, Medals, Busts, Small Statues, and Bas-Reliefs* (1779), E50-29997

22. Column vases appear as 'rute' or 'flower pots' in the Oven Books. Information taken from *Ars Ceramica*, no. 11 (1994)

23. Memoranda, Byerley 1779–1789 'Prices rec[eive]d from Etru[ri] a June 1786.', (1779–89), E45-29110

24. J.W. to Thomas Bentley, January 1768 (no precise date), E25-18183

25. See David Bindman, *The Shadow of the Guillotine: Britain and the French Revolution*, with contributions by Aileen Dawson and Mark Jones (London 1989)

26. Founded on 22 May 1787

27. Equiano, a prominent Georgian writer, had himself escaped enslavement and went on to publish his autobiography, *The Interesting Narrative of the Life of Olaudah Equiano*, in 1789. He is the first known individual to buy the rights to his own portrait.

28. Abolition was achieved in 1807, although emancipation of enslaved people was not enacted until 1834. Wedgwood's daughter Sarah was a founding member of the first women's abolitionist society, the Birmingham Ladies Society for the Relief of Negro Slaves, and his son Josiah II stood as a Member of Parliament for Stoke-on-Trent on an abolitionist platform.

29. Wedgwood and Bentley, *A Catalogue of Cameos, Intaglios, Medals, Busts, Small Statues, and Bas-Reliefs* (1779), E50-29997

30. E12-11272

31. Maureen Batkin, *Wedgwood Ceramics 1846–1959: A New Appraisal* (London, 1982), p. 90

32. The inkstand was originally introduced in 1780 in black basalt.

33. This shape is first recorded on 31 January and 7 February 1784, Oven Books, E53-30015.

34. Cecil Wedgwood to W.J. Furnival, 11 September 1902, MS E62-33507

35. Murray designed the factory in partnership with the architect C.S. White, although in the 1930s he had struggled to find work as an architect, hence the switch to ceramics.

36. Batkin, p. 226

37. Richard Dennis, *Ravilious and Wedgwood: The Complete Wedgwood Designs of Eric Ravilious* (London, 1995), p. 46

38. *Wedgwood Counterpoint* (Christmas 1973)

39. 'Setting the Table for the Seventies', *Wedgwood Review*, vol. 5, no. 2 (March 1970)

40. *Glenys Barton at Wedgwood* (London 1977)

41. See www.scottish-gallery.co.uk/news/2020/wendys-world-a-tribute-to-wendy-ramshaw-part-one

Select Bibliography

Maureen Batkin, *Wedgwood Ceramics 1846–1959: A New Appraisal* (London, 1982)

Anthony Burton, *Josiah Wedgwood: A New Biography* (Barnsley, 2019)

Aileen Dawson, *Masterpieces of Wedgwood in the British Museum* (London 1984)

Richard Dennis, *Ravilious and Wedgwood: The Complete Wedgwood Designs of Eric Ravilious* (London, 1995)

Brian Dolan, *Josiah Wedgwood: Entrepreneur to the Enlightenment* (London, 2004)

Ann Eatwell, *Susie Cooper Productions* (London, 1987)

Patricia F. Ferguson, *Garnitures: Vase Sets from National Trust Houses* (London, 2016)

Brian D. Gallagher, with contributions by Gaye Blake-Roberts, Robin Emmerson, Nancy H. Ramage and M.G. Sullivan, *Classic Black: The Basalt Sculpture of Wedgwood and His Contemporaries* (Charlotte, NC, and London, 2020)

Sharon Gater and David Vincent, *The Factory in a Garden: Wedgwood from Etruria to Barlaston – The Transitional Years* (Keele, 1988)

Philippa Glanville and Hilary Young (eds), *Elegant Eating: Four Hundred Years of Dining in Style* (London, 2002)

Robin Hildyard, *European Ceramics* (London, 2009)

Tristram Hunt, *The Radical Potter: Josiah Wedgwood and the Transformation of Britain* (London, 2021)

Robin Reilly, *Josiah Wedgwood 1730–1795* (London, 1992)

Robin Reilly, *Wedgwood: The New Illustrated Dictionary* (Woodbridge, 1995)

Bruce Tattersall, *Stubbs and Wedgwood: Unique Alliance Between Artist and Potter* (London, 1974)

Jenny Uglow, *The Lunar Men: The Friends Who Made the Future* (London, 2002)

James Walvin, *Slavery in Small Things: Slavery and Modern Cultural Habits* (Chichester, 2017)

Susan Weber et al., *Majolica Mania: Transatlantic Pottery in England and the United States, 1850–1915* (New Haven and London, 2020)

A.N. Wilson, *The Potter's Hand* (London, 2012)

Hilary Young (ed.), *The Genius of Wedgwood* (London, 1995)

Picture Credits

Acknowledgments

This celebration of the V&A Wedgwood Collection has been made possible with the help of many colleagues and Wedgwood enthusiasts. From the V&A, I am grateful to Jane Ace and Hannah Newell from the publishing team, to Tristram Hunt and to the fantastic V&A Wedgwood Collection team: Isabel Clanfield, Kate Turner, Michael Ruddy, Randeep Atwal, Rebecca Klarner, and particularly Lucy Lead for her knowledge and insights. Thanks to Kevin Percival for his new photography, to Aileen Dawson for her insightful comments on the text, to Simon Wedgwood and to Edward Austin.

Author Biographies

Catrin Jones is Chief Curator of the V&A Wedgwood Collection. A specialist in ceramics and silver, she has held curatorial posts at the Holburne Museum, the Ashmolean Museum, the Museum of the Home and the Victoria and Albert Museum. She read History of Art at the University of Oxford and completed her Masters at the Courtauld Institute, where she specialized in the eighteenth-century French interior, and recently completed an MBA in Leadership. Her publications include *Grayson Perry: The Pre-Therapy Years* (2020); 'Ellen Tanner's Persia: A Museum Legacy Rediscovered' for the interdisciplinary Journal *19*; and a contribution to the British Museum Research publication *Pots, Prints and Politics: Ceramics with an Agenda, from the 14th to the 20th Century* (2021). She is a Trustee of the Clay Foundation.

Tristram Hunt is the Director of the Victoria & Albert Museum. Prior to joining the V&A in 2017, Dr Hunt was Labour MP for Stoke-on-Trent Central and Shadow Secretary of State for Education. He has a doctorate in Victorian history from Cambridge University. His publications include *Ten Cities that Made an Empire* (2015) and *The Radical Potter: Josiah Wedgwood and the Transformation of Britain* (2021).

Front cover image: Detail of the first edition copy of the Portland Vase, 1790 (p. 23) with the 'Apotheosis of Homer' vase, 1786 (p. 63) in the background.
Back cover image: 'The Great Exhibition 1851 – Industry of All Nations: Etruria & Wedgwood', Illustrated Art Catalogue, 1851 (p. 83).
Opposite title page: 'First Day's Vase', 1769, V&A: WE.7568-2014 (p. 45).
Opposite contents page: Advert for Bas-relief ware, 1912, V&A Wedgwood Collection, Barlaston (V&A Wedgwood Collection Archive).

First published in the United Kingdom in 2023 by
Thames & Hudson Ltd, 181A High Holborn, London wc1v 7qx
in association with the Victoria and Albert Museum, London

First published in the United States of America in 2023 by
Thames & Hudson Inc., 500 Fifth Avenue, New York, New York 10110

Wedgwood: Craft & Design © 2023 Victoria and Albert
Museum, London/Thames & Hudson Ltd, London

Text and V&A photographs © 2023 Victoria and Albert Museum, London
Design © 2023 Thames & Hudson Ltd, London

British Library Cataloguing-in-Publication Data
A catalogue record for this book is available from the British Library

Library of Congress Control Number 2022945833

ISBN 978-0-500-48075-5

Printed and bound in China by C & C Offset Printing Co. Ltd

Be the first to know about our new releases,
exclusive content and author events by visiting
thamesandhudson.com
thamesandhudsonusa.com
thamesandhudson.com.au

V&A Publishing
Supporting the world's leading
museum of art and design,
the Victoria and Albert
Museum, London